Луна

Марс

советские
космические
собаки

Text **Olesya Turkina**
Translated by **Inna Cannon, Lisa Wasserman**

Images compiled by **FUEL, Marianne Van den Lemmer**
Edit and Design **Murray & Sorrell FUEL**

soviet
space
dogs

FUEL

Contents

вселенная
полна
совершенных
существ

Envelope, USSR (1961)
Text reads '**The universe is full of the life of perfect creatures. K. E. Tsiolkovsky**'. A quote from Tsiolkovsky's book *The Scientific Ethics* (1930).

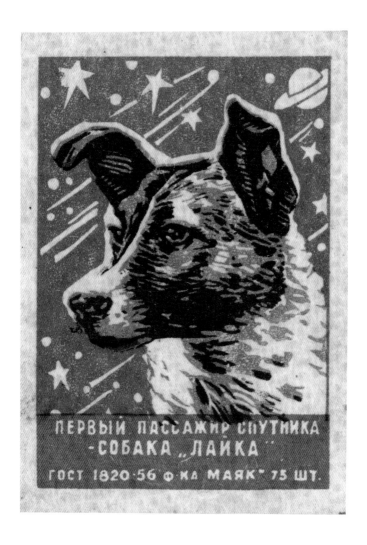

Matchbox label, USSR (c.1957)
One of many label designs celebrating the first living being in space. Text reads
'**The First Sputnik Passenger – the dog "Laika"**'.

Laika, Belka and Strelka – these are the most famous space
dogs. Today they are household names: in whichever language
these words are spoken, everyone understands that you are
talking about the first travellers to reach orbit. These dogs are
the characters in a fairy tale that was created in the USSR:

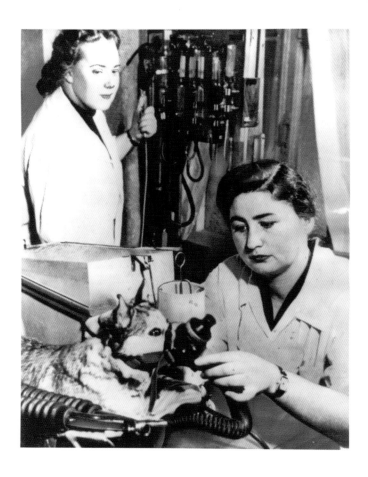

they are the martyrs and saints of communism. Their fate is the embodiment of a utopian consciousness, the ideal of a society that lived in the future, a society whose aim was to turn a fairy tale into reality.* These strays had to endure inhumane tests, and either perished, giving their lives for the Motherland to become posthumous heroes, or found themselves the adored darlings of the nation. The lucky ones lived out their days in the laboratory, where devoted attendants would chew bits of (hard-to-find) sausage before feeding it to the dogs who had

* The first line from a song that became the official march of the Soviet Air Force in 1936: We were born to make fairy tales come true / To overcome distance and space / Our intelligence gave us steely hand-like wings / And a fiery engine instead of a human heart.

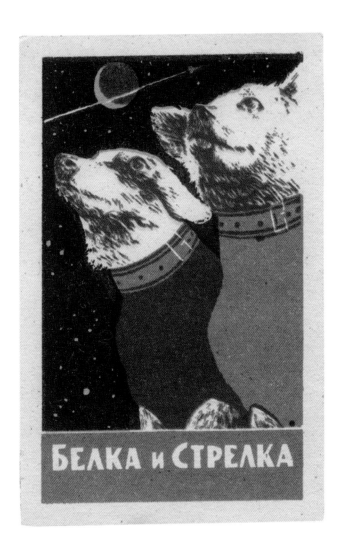

БЕЛКА и СТРЕЛКА

above: **Matchbox label, USSR** (1963)
A matchbox label from the souvenir set *The Way to the Stars*. Text reads '**Belka and Strelka**'.

left: **Testing and training the dogs in the laboratory** (1958)
Physician Ada Kotovskaya (right) holds breathing apparatus over the nose of a dog named 'Alpha', during training exercises for high-altitude flights. In the background her assistant S. Sebesko looks on. Kotovskaya previously trained Laika for her flight in Sputnik 2.

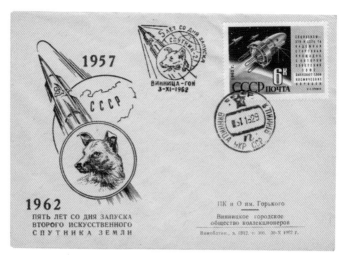

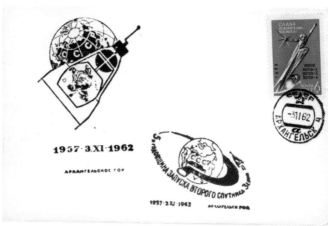

top: **Laika Five Year Anniversary Envelope, USSR** (1962)
Top text reads '**5 Years since the launch of Sputnik 2. Vinnitsa – Goi 3.XI.1962**'.
Text around the portrait reads '**1957–1962 USSR. Five years since the launch
of the second artificial Earth satellite**'.

bottom: **Laika Five Year Anniversary Envelope, USSR** (1962)
Text on the franking mark reads '**5th Anniversary of the Launch of the Second
Sputnik. Arkhangelsk**'.

right: **Laika Five Year Anniversary Envelope, USSR** (1962)
Portrait text reads '**Laika 1957–3.11–1962, The First Living Creature in Space**'.
Text around the rocket reads '**5 Years from the Date of the Flight, Magadan**',
text on the rocket reads '**Laika**'.

lost their teeth in the battle to colonise space. Alternatively, they were taken home as pets by scientists in reward for their loyalty and endurance, and as a consequence of the mutual affection that had developed during their shared toil, (not to mention a sense of guilt on the side of the scientists).

The dogs were simultaneously real and fantastical beings. One day these unknown strays were living on the street, the next they were shown on television, and their portraits published in newspapers. They were assigned their 'Road to Life',* and given heroic names as a reward for their immeasurable contribution to human progress. They also became characters in children's books, but this was a new kind of fairy tale, recorded in a different way. The portrayal of the dogs contrasted with traditional folklore. They didn't speak in human voices, they could only think things to themselves, so the writer would have to imagine their thoughts! With rare exceptions, they were never presented as sly tricksters, like their historical canine predecessors, but neither were they depicted as easily fooled simpletons. The characterisation of

* The name of a 1931 Soviet film directed by Nikolai Ekk, which follows the rehabilitation of a group of homeless children who progress to become builders of Communism.

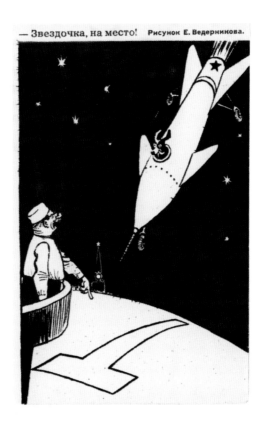

— Звездочка, на место! Рисунок Е. Ведерникова.

above: **Newspaper drawing, USSR** (c.1961)
Text on the left reads '**Zvezdochka, heel!**'. Text to the right reads '**Drawing by E. Vedernikov**'.

right: **Postcard, USSR** (1962)
A postcard from the Rosprom Board Research Institute of Toys depicting a carved bear holding the Earth as it is orbited by Sputniks 1, 2 and 3. Carving by N. Maksimov, Bogorodskoye, Moscow Region.

the space dogs was not a continuation of the established conventions of the animal epic, although it did give a new perspective on the allegory of loyalty. These dogs were the pioneers for human kind. Not only for the idea of the single hero, but crucially, for all humanity.

This new myth, created in front of a watching world, occurred at the crossroads of the USSR's utopian ideology and its achievements in space as a concrete manifestation of that

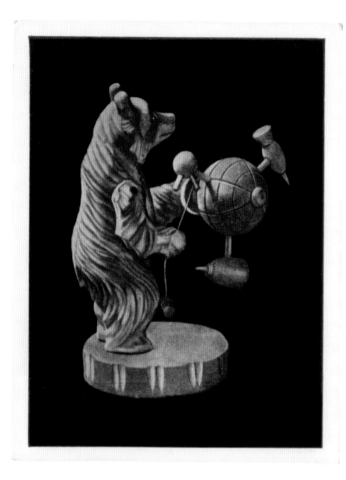

utopia. The space dogs' story retained its sacred character even after the collapse of the USSR. This is why, until very recently, there were no comic strips on the subject (a further explanation for this is that in the USSR comics were considered a bourgeois genre and were effectively banned). Despite the ideological friction with this medium, the country produced many humorous captioned drawings on the theme, which were extraordinarily popular. Like the first cosmonaut, the space dogs became an incontrovertible manifestation of the superiority of the Soviet way: they were proof that the correct path was being followed. Popular science films dedicated to the colonisation of space

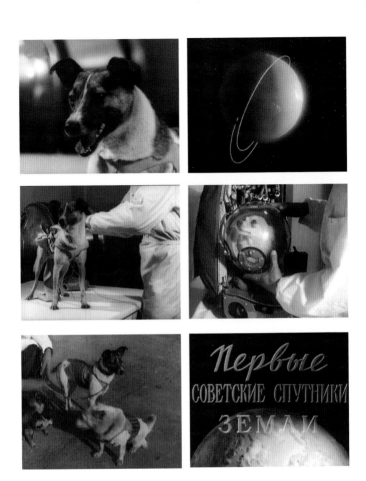

used documentary footage of the dogs taken just before their flights. This was then superimposed onto animated rockets with the same build and trajectory as the Soviet satellites.

This technique helped to keep the nature of the characters real. In stories, poems, newsreels and films, they became living legends: the cosmonaut dogs that performed intrepid feats. The thin line between reality and fiction remained intact until the release of the animation *Belka and Strelka: Star Dogs* (2010). Created by Svyatoslav Ushakov and Inna Evlannikova, it presented the dogs as the canine equivalent of imaginary superheroes such as Spiderman. The character of Belka as

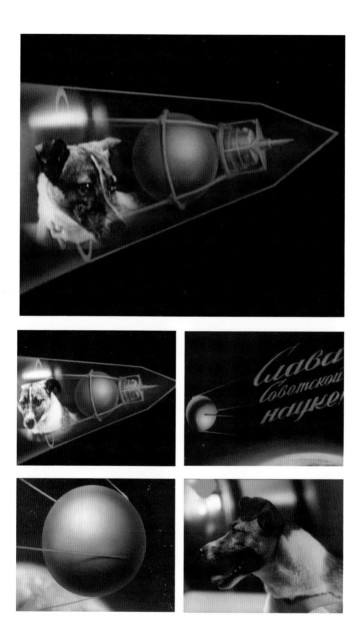

above and left: ***The First Soviet Earth Sputniks*, USSR** (1957)
Stills from the film which show Laika 'on board' (superimposed on top of)
Sputnik 2, and a number of other space dogs.

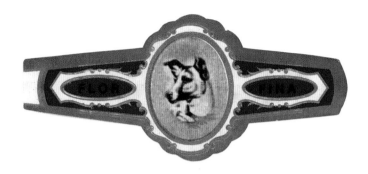

above: **Cigar band, Spain** (c.1965)
A cigar band with a portrait of Laika, one of a series dedicated to Soviet and American early achievements in space. Spanish text reads '**FINE GRAIN**'.

right: **QSL radio card, USSR** (1967)
QSL cards were used to confirm communication between amateur radio users. Details of the contact were documented on one side of the card, while the other often carried a picture or event specific to the country of origin. This radio card commemorates the 50th anniversary of the Russian Revolution. It depicts several landmarks of Soviet achievement: the red flag of revolution; The Worker and the Collective Farm Woman statue; the symbol for atomic power; the Monument to the Conquerors of Space; and the Moscow State University building.

created by the Russian animators was even compared to the dog Bolt from the American cartoon of the same name made by Chris Williams and Byron Howard in 2008. Despite adhering to the facts, by referencing aspects of American mass culture, the film tainted the Soviet myth of the space dogs. This corruption of the collective Soviet childhood denied Belka and Strelka their inimitable place in history, confusing the dogs with the system that created them.

When the world expanded beyond the USSR, Russians discovered that their Soviet heroes, the first canine cosmonauts, were also known and revered in other countries. I'll never forget how stunned I was by the Soviet space dogs' Hall of Fame, at

the Museum of Jurassic Technology in Los Angeles. M.A. Peer's arresting portraits of Laika, Belka and Strelka, Zvezdochka and Ugolyok gazed down proudly from golden frames. The walls of the museum were clad in red velvet and decorated with the words of Konstantin Eduardovich Tsiolkovsky*: 'All the universe is full of the life of perfect creatures'. A few years after this encounter, the space dogs flew across the ocean to the Museum of Cosmonautics and Rocket Technology, at the Peter

* Tsiolkovsky (1857–1935) was a pioneering rocket scientist and founder of astronautic theory. His works were a great influence on future generations of scientists, who were able to transform many of his theories into reality.

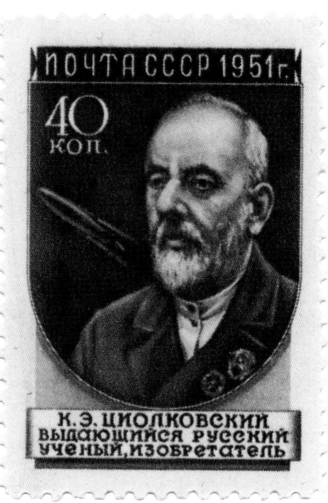

and Paul Fortress in St Petersburg (previously the Gas Dynamics Laboratory, where studies into the practical colonisation of space began in the 1930s). Here they were displayed on the 'flight deck' of the Tsiolkovsky Hall, underneath a replica of the first Sputnik. Because of a small mistake in the official paperwork, the portraits of the space dogs were delayed in Russian customs for a few days. As the coordinator of the exhibition, I had to make phone calls and write letters about

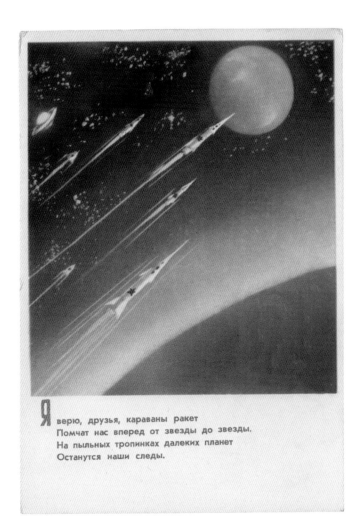

Я верю, друзья, караваны ракет
Помчат нас вперед от звезды до звезды.
На пыльных тропинках далеких планет
Останутся наши следы.

above: **Postcard, USSR** (1962)
Soviet rockets conquering space by the artist N. Popov. Poem reads
'**I believe, friends, caravans of rockets**
Will rush us forward from star to star,
On the dusty paths of far planets
Our footprints remain'.

left: **Stamp, USSR** (1951)
A stamp honouring Tsiolkovsky. Text reads '**USSR Post 1951. 40 kop**[ecks].
K. E. Tsiolkovsky. **O**utstanding **R**ussian scientist, inventor'.

these pictures of the heroic Soviet cosmonaut dogs to ensure that they could be put on show in their Motherland. That was when the power of the space myth demonstrated itself fully. Both officials and simple acquaintances were so moved by the fate of the Soviet space dogs that they made every possible effort to arrange for their timely landing at the museum.

The space myth died with the dissolution of the USSR, but the compassion and love for its fairy-tale heroes remained, as their story, full of tragedy, possesses very human characteristics.

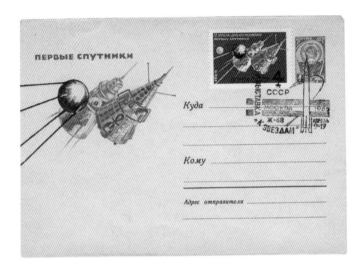

top left: **Matchbox label, USSR** (1969)
Text reads '**1957. Earth's first artificial satellite**'.

bottom left: **Matchbox label, USSR** (1959)
A label showing the first three Sputniks and Luna 1 (the first object to escape Earth's gravity).

top: **Envelope, USSR** (1965)
Text reads '**First Sputniks**', postmark reads '**Exhibition IV "To the Stars" Moscow, 9–19 April 1965**'.

bottom: **Sputnik razor blades, USSR** (1958)
Razor blades celebrating the first Soviet Sputnik flight in 1957.

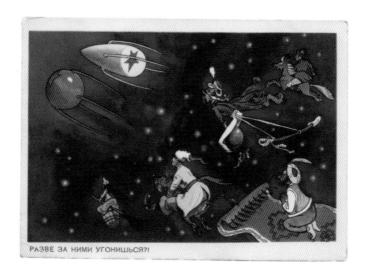

РАЗВЕ ЗА НИМИ УГОНИШЬСЯ?!

The collective memory of these pioneers of the cosmos can never be replaced with that boring word 'modernisation', the Soviet space dogs have ascended to their rightful place in the ideological pantheon. It is no coincidence that representations of space dogs have become a popular theme for collectors. They are part of the Soviet consciousness, part of the utopia that promised to deliver the very best to humanity. It is not the fault of the space dogs that such hopes were never fulfilled! They more than exceeded themselves in their service to man. Today, there is a veritable zoo in orbit: birds' eggs are sent up to hatch orbital chickens, fish, simple organisms and plants are common cargo. Will space travellers bring canine travelling companions on their long voyages, or will the ethics of the future prohibit this? The space myth leaves us with its traces – postage stamps, matchbox labels, cigarette packets, badges, postcards, children's books...

Space dogs were part of Soviet propaganda, perhaps in its most demonstrative form. Unlike Yuri Gagarin, the first human to orbit the Earth, Laika, Belka, Strelka, Zvezdochka and many other members of the order of four-legged cosmonauts have no past, no background in the traditional sense of the word.

above: **Postcard, USSR** (1959)
Orbiting the Earth are the first three Sputniks, top left is the rocket Luna 1, the first man-made object to escape Earth's gravity. The flags represent the different socialist republics of the USSR. Text on the reverse reads '**2nd January, 1959. The first space rocket is launched by the Soviet Union**'.

left: **Postcard, USSR** (c.1959)
An image by the artist I. M. Semenov, linking fact with fiction. It features fairy-tale characters all of whom had rapid means of transportation. They are attempting (and failing) to match the superior speed of Sputniks 1 and 2. The text reads '**Catch them if you can?!**' The protagonists are (left to right): Baba Yaga (broomstick); Ivan (humpbacked pony); Baron Munchausen (cannon ball); Vakula (riding the devil in the form of a horse); Prince Hussain (magic carpet).

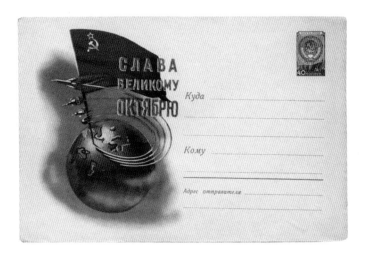

above: **Envelope, USSR** (1959)
An envelope marking the success of the Soviet Space Programme showing the first three Sputniks and Luna 1. Text reads '**Glory to Great October**'.

top right: **Mondorama Card, Italy** (c.1960)
The back of the card explains how Laika was 'the first living being to confront the unknowns of space'.

middle right: **Tea Card, Great Britain** (1960s)

bottom right: **Edizioni Lampo Card, Italy** (1959)
From the series *The World of the Future*, the image shows a cutaway Sputnik 2.

The story of their lives began at the Institute of Aviation Medicine,* and ended there. The scientific biography of a Soviet space dog is a life described solely in biological parameters. It was left to the ideology of the Soviet system itself to proclaim the story of their epic feats.

Not even perestroika† could displace their mythical status. As with many other unknown facts from Soviet history that only came to light following the collapse of Communism, the secret experiments in space colonisation in which these brave dogs

* The centre where the dogs were trained. On 25 October 1957, in a live broadcast from the Institute, Laika (at that time named Kudryavka) barked on air for the radio audience.
† Perestroika: literally 'restructuring', was a Soviet government initiative undertaken in the 1980s during the leadership of Mikhail Gorbachev. It attempted to reform the stagnant policies of the Communist Party to allow for greater political and economic freedom. Banned books were allowed to be published, and the censorship that was previously a feature of the regime was relaxed.

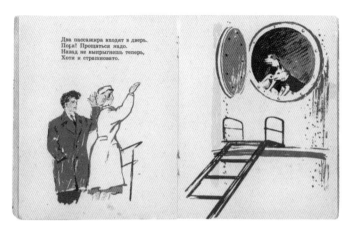

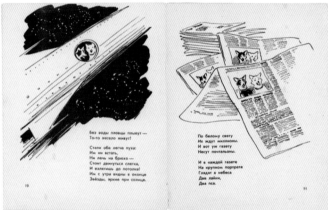

top: ***Star Travellers***, **USSR** (1962)
A spread from the children's book by Yuri Yakovlev that tells of the adventures of Belka and Strelka. Text reads '**Two passengers walk through the portal / It's time! We have to bid farewell / We can't jump out, we're now immortal / Do you smell our fear? It surely tells!**'

bottom: ***Belka and Strelka, and Their Journey***, **USSR** (1964)
A spread from the children's book by M. Poznanskaya. Text reads '**Swimmers swimming without water / Oh, what joy their lives have brought them!**'; '**Now floating lighter than a feather: / No standing up, no lying down, / Would hit the walls, were they not tethered! / And see the earth in sunny weather**'. '**And millions saluted them / from all the world, / awaited the postmen / to bring the word**'; '**for in each paper / their image shines / two Laikas / two dogs, / staring at the skies**'.

right: ***Belka and Strelka, and Their Journey***, **USSR** (1964)
The cover of the children's book by M. Poznanskaya.

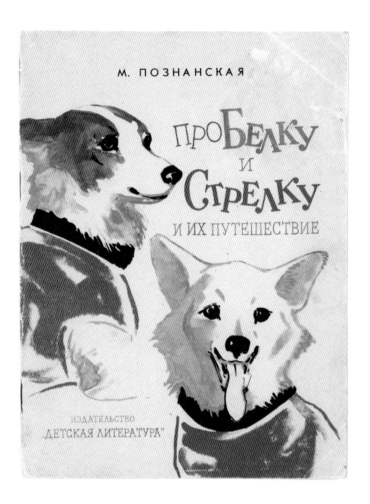

М. ПОЗНАНСКАЯ

про Белку
и
Стрелку
и их путешествие

ИЗДАТЕЛЬСТВО
"ДЕТСКАЯ ЛИТЕРАТУРА"

were used have now been declassified. Scientists have confessed to the torment and misery of Laika, who died only a few hours after the launch of her orbital flight. They have revealed the technicalities of their programme, details of the dogs who took part, and which of these heroes died in the quest to conquer the cosmos. Eventually, memorials were erected to these champions of the Socialist state. Space dogs have much in common with cosmonauts: not only because they were sent into space, but also the attitude towards them. Yuri Gagarin's flight was entirely automated, controlled by

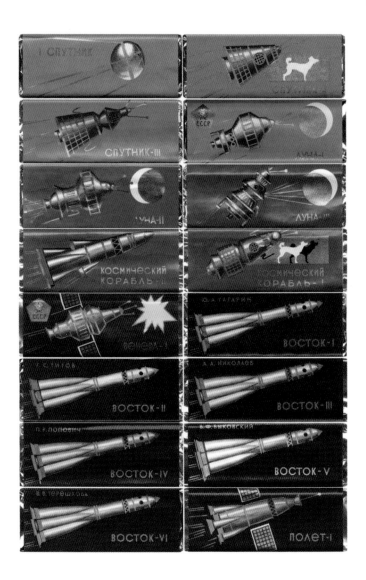

above: **Cosmos chocolates, USSR** (1971)
Chocolates displaying spacecraft from the Soviet space programme. Laika, Belka and Strelka are shown as silhouettes next to their respective spacecraft.

right: **Routine weight check for Chernushka** (1958)
Lyudmila Radkevich, Associate Researcher at the Institute for Aviation and Space Medicine, checks Chernushka's weight in the laboratory.

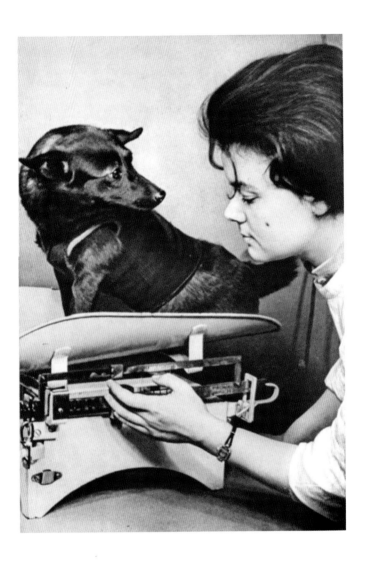

systems within the spacecraft and on the ground. He is said to have joked 'Am I the first human in space, or the last dog?' Even if this story is fictitious, it is a reflection of the myth of the space dogs. Like the cosmonauts, they suffered in obscurity before their flight, but enjoyed universal fame and material rewards (including all the sausage they could eat) after a successful landing.

QSL radio card, USSR (c.1958)
Text above reads '**Soviet Satellites – the First in the World** '. This QSL radio card shows the first two Sputnik spacecraft in orbit.

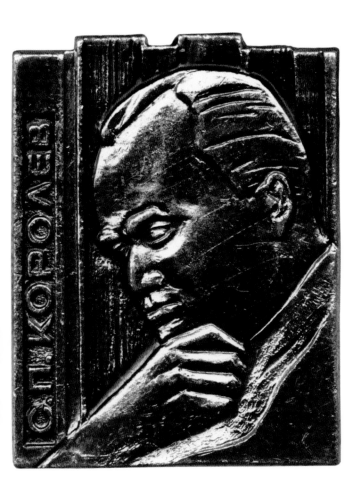

Brass badge, USSR (1970s)
A metal portrait lapel badge showing Sergey Korolev deep in thought. Text reads '**S. P. Korolev**'.

Experiments involving space dogs began in the aftermath of the Great Patriotic War (World War II). Sergey Pavlovich Korolev, the genius engineer and designer who had been denounced and arrested in 1938, was allowed to continue his work on rocket engines while imprisoned in a *sharashka* (a prison for intellectuals and the educated). Both he and his projects were kept top-secret by the state. Following his release

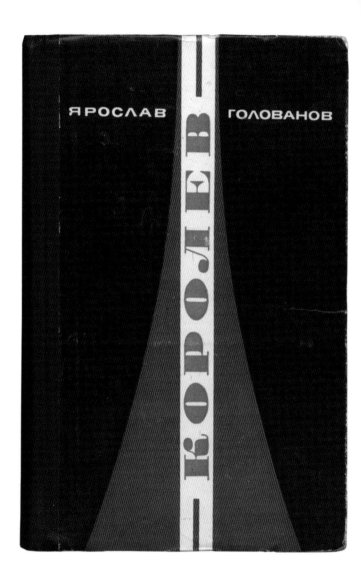

above: **Cover of the book *Korolev*, USSR** (1973)
A biography of the Chief Designer produced by Young Guard Publishers (Moscow).
Text reads '**Korolev, Yaroslav Golovanov**'.

right: **Laika enamel badge, USSR** (c.1960)
Text reads '**First Sputnik Passenger Laika**'. Text on the rocket reads '**USSR**'.

early in 1944, he was given the task of creating the equivalent of Werner von Braun's V2 rocket*. In 1946, a special government resolution on jet-propelled armaments was passed. In the same year Korolev witnessed an impressive demonstration of the V2, given by the British Allies in Germany.

What is most important to the space dog odyssey, is that the future Chief Designer had always dreamed of piloted space flight. Similarly, interplanetary flight had been the main goal of Konstantin Eduardovich Tsiolkovsky, the father of Soviet cosmonautics, as well as Friedrich Arturovich Zander,[†] the pioneer of rocket technology, whose ambition it was to fly to Mars. It was also the favourite storyline of countless science fiction writers, who used spaceships to send their protagonists on exciting adventures. In their imaginations, the rocket was

* The V2 was the first ballistic missile and the first human artifact to reach space. It was developed for Nazi Germany by the scientist Werner von Braun, and used against London and other cities during World War II. At the end of the war von Braun was captured by Allied forces and his knowledge used by America in the space race against the USSR.

[†] Zander (1887–1933), was a leading scientist who, as well as making many theoretical discoveries, also designed the first liquid-fuelled rocket to be launched in the USSR.

above: **Matchbox label, Germany** (1963)
A matchbox label showing a V2 rocket. Text reads '**V 2 Germany. The idea of shopping at VéGé** [the Dutch National Association of Independent Grocers]'.

right: **Matchbox label, USSR** (1963)
A portrait matchbox label from the souvenir set *The Way to the Stars*. Text reads '**F. A. Zander**'.

not conceived as a weapon that could cross great distances to strike an enemy, but as a means of reaching outer space: first Earth's orbit, then other worlds. A clear example of this is Tsiolkovsky's agitation on seeing an article published in Issue 115 (1905) of the newspaper *Birzhevye Vedomosti* (*Stock Exchange Bulletin*). Reporting on an American company that

Ф. А. ЦАНДЕР

had supposedly invented a combat missile, it stated: 'During a series of tests yesterday, thousands of the newly invented mines flew through the air, dispersing bullet-filled shells over a great distance.' The news turned out to be false, but Tsiolkovsky was convinced that the creation of such a missile was possible; this belief was supported by his own theory, which had been published two years earlier. He wrote to the newspaper's editor:

'This telegram drove me to sorrowful reflections. I ask for your permission to share them with the readers, because of their instructiveness. Exactly

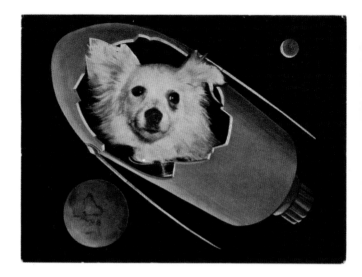

two years ago – in May 1903 – Issue 5 of the *Nauchnoye Obozreniye (Science Review)* published my mathematical work: *The Exploration of World Spaces by Jet-Propelled Devices* (comprising two printed sheets). It essentially lays out the theory of a gigantic rocket that lifts humans, and even bears them (under certain conditions) to the Moon and other heavenly bodies. And now the worldwide sharks (as Edison* calls the stealers of others' thoughts) have already managed to partially confirm my ideas, and, unfortunately, apply them for destructive purposes. I have never worked on perfecting the means of waging war. This is abhorrent to my Christian spirit. In working on jet-propelled devices, I had peaceful and lofty goals: to conquer the universe for the benefit of mankind, to conquer space and the energy issued by the Sun.'

* A reference to the inventor Thomas Edison (1847–1931). The practice of selling or licencing patents to inventions was commonplace during his time. Some buyers were known as 'sharks' because of the way they ruthlessly exploited their acquisitions, often at the expense of the development of the industries in which they could be applied.

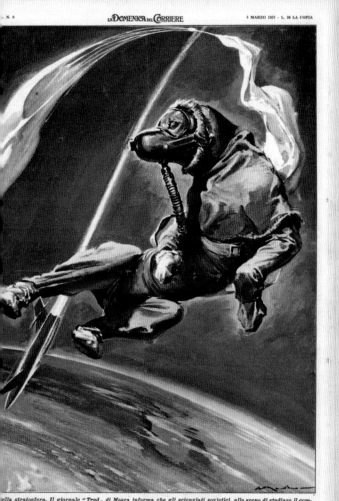

ella stratosfera. Il giornale "Trud„ di Mosca informa che gli scienziati sovietici, allo scopo di studiare il com-
ento di esseri viventi oltre i confini dell'atmosfera, hanno lanciato, per mezzo di razzi, alcuni cani fino a 110
altezza. Nel corso di un esperimento sono stati impiegati cani rivestiti di speciali tute spaziali e provvisti
rve di ossigeno. A 80.000 metri le bestiole, che erano chiuse nella parte anteriore del razzo, sono state cata-
all'esterno. Esse sono scese a terra, col paracadute, incolumi e in condizioni normali. *(Disegno di Walter Molino)*

above: *La Domenica del Corriere* **magazine, Italy** (1957)
An artist's impression of a dog parachuting from a rocket. The Italian text tells
of how dogs have been taken up to a height of 100 km so that Soviet scientists can
study how they are affected. Illustration by Walter Molino.

left: **Postcard, Italy** (c.1960)
A postcard with an image of Kozyavka (wrongly named as Laika on the reverse).

БЕЛОРУССКИЙ СНХ БОРИСОВСКИЙ Ф/С КОМБ.
ГОСТ 1820-56* 60 ШТ. Ц. 1 КОП. 1963 Г.

К.Э.Ц

The letter was never published, and is now kept in the Tsiolkovsky collection at the Russian Academy of Sciences. The scientist had plenty to complain about. The first publication of his revolutionary theory went almost entirely unnoticed. *The Exploration of Cosmic Space by Means of Reaction Devices* was published in reduced form in 1903, as part of a literary-philosophical almanac; most of the print run was confiscated under censorship laws. It was not until 1911 that

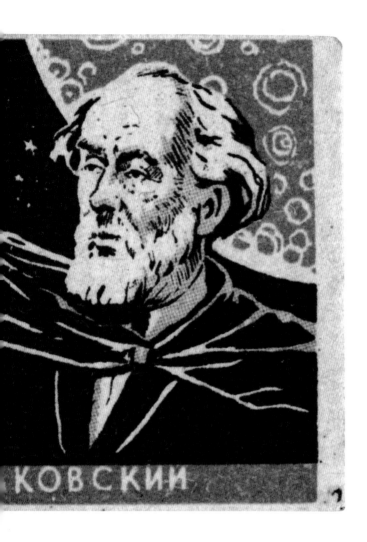

Matchbox label, USSR (1963)
Text reads '**K. E. Tsiolkovsky**'.

the magazine *Vestnik Vozduhoplavaniya* (*Aeronautics Herald*) published the second part of his work, in which Tsiolkovsky not only presented the calculations for exceeding the force of Earth's gravity, but also proposed the idea of an autonomous life support system for spaceships. It was this publication, which contained a reference to the 1903 edition, that established

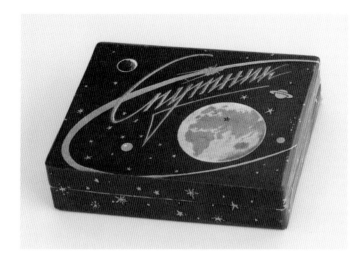

Tsiolkovsky's precedence over the French and American scientist-inventors Robert Esnault-Pelterie (1881–1957) and Robert Goddard (1882–1945).

The exploration of prospective interplanetary flight had to go beyond the development of rocket technology: it was necessary to understand whether a 'passenger' (in Tsiolkovsky's time also called a rocketeer or a starflyer*) would be able to bear the hardships of take-off: strong vibration and multiplied gravitational forces, followed by weightlessness and cosmic radiation. As early as 1897, Tsiolkovsky conducted tests on the effects of increased gravity on living organisms using a centrifuge of his own invention. With this machine, built from available parts, he was able to increase the weight of a red cockroach by a factor of 300, and the weight of a chicken by a factor of 10. The experiments were completed without apparent harm to the subjects. His notebooks contain drawings and calculations concerning the changing gravity of a swing, a train carriage, and the inside of a cannonball: evidence of his particular interest in the effects generated by the accelerated movement of bodies. In his subsequent work,

* The word 'cosmonaut' only appeared in the works of Ary Sternfeld in 1937 and didn't gain widespread use until Gagarin's flight in 1961.

above and left: **Sputnik cigarettes, USSR** (c.1958)
The lid of the box shows Sputnik 2 orbiting the Earth (Moscow is marked with a red star), text reads '**Sputnik**'. The interior of the box has a portrait of its passenger, Laika.

Tsiolkovsky suggested that the impact of gravity on rocketeers could be mitigated by the use of special oil baths, in which they were to be submerged during take-off. He promptly dismissed the idea of launching travellers to the Moon by means of a Columbiad cannon, as depicted in Jules Verne's 1865 novel *From the Earth to the Moon*, recognising that the gravitational forces involved could not be tolerated by a living organism. The 'passengers' would literally be flattened during take-off.

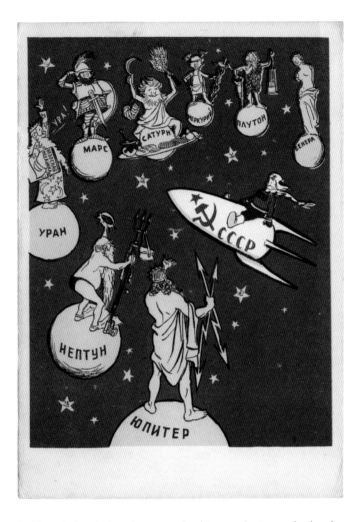

In Verne's book the character Barbicane devises a hydraulic shock absorber to relieve the rapid acceleration of the launch. An initial test is carried out using a hollow shell containing a cat and a squirrel, fired at low altitude. The cat tolerates the take-off and landing well; the same cannot be said of the second passenger, who is eaten during the short voyage. On their journey to the Moon, the three protagonists, Impey Barbicane (president of the Gun Club), Captain Nicholl, and Michel Ardan, are accompanied by two appropriately

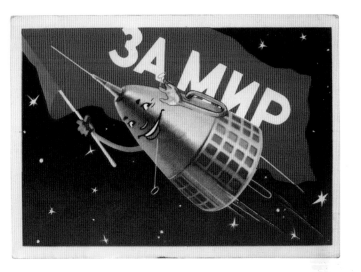

above: **Postcard, USSR** (1961)
A card by the artist G. Bedarev, celebrating the three year anniversary of the launch of Sputnik 3. Text on the flag reads **'For peace'**.

left: **QSL card, USSR** (1959)
This card shows a young cosmonaut sitting on a Sputnik, meeting the collected planets. Text on the planets (clockwise from bottom) reads '**Jupiter; Neptune; Uranus; Mars; Saturn; Mercury; Pluto; Venus**'. Text on the rocket reads '**USSR**'. The title of the book carried by Uranus is '**Celestial Mechanics**', he is shouting '**Hurrah!**'.

named dogs – a Newfoundland called Satellite, and a hunting bitch called Diana. The indefatigable Ardan, who has decided to breed a new species of 'moon dog', also brings a small cosmic zoo, including half a dozen hens and a rooster, intending to let them loose on the Moon in order to astonish his friends.

In the novel's 1869 sequel, *Around the Moon*, Verne describes how the violent impact of take-off causes the death of Satellite. The dog never fully recovers from the head injuries he sustains, and eventually expires right there, inside the cosmic missile. His body, carefully ejected through the porthole (that a window might be opened in space without consequence is one of the writer's more fantastical assumptions), became the first piece of space debris, flying behind the rocket.

Why were dogs the first creatures to explore Soviet space? This question was answered by the scientists themselves, who were only able to disclose many details of the canine space programme after perestroika. However, it is difficult to determine truth from legend, as the participants – both the scientists and their subjects – have long since passed into legend themselves. It's possible that the use of dogs in the space programme was partially influenced by the famous

Postcard, USSR (1958)
An image by A. Ivanov of a Soviet rocket leaving Earth's orbit and heading towards the Moon. Text reads '**Happy New Year**'.

physiologist Ivan Petrovich Pavlov (1849–1936). He studied the reflex system, using dogs to help prove his theories (in the process giving rise to the term 'Pavlov's dog'). This method became the standard for scientific testing. It is conceivable that the Soviet authorities were particularly fond of Pavlov, not only

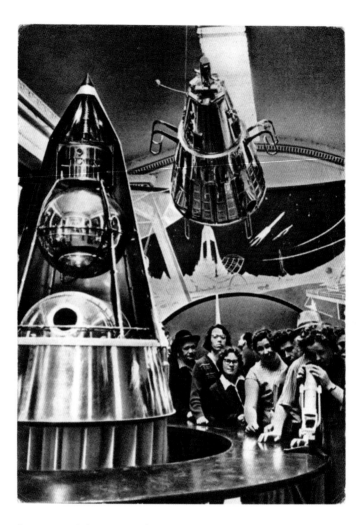

because of the materialistic nature of his research, but also
because they were hoping to develop the conditional and
unconditional reflexes of a new type of Soviet human, raised
for the benefit of progress. A human capable of self-sacrifice.

In an interview, Viktor Borisovich Malkin (who worked at
the Institute of Aviation Medicine at the time), explained
why dogs in particular were chosen. Logically, the first creature
sent into space should be an ape, as they have a much closer
resemblance to man. Doctor Oleg Georgiyevich Gazenko, one

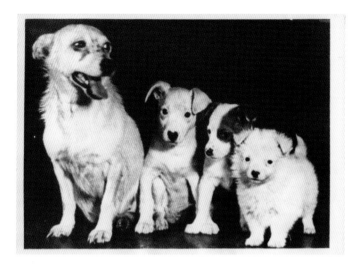

above: **Albina and puppies** (1959)
Press photographs like this were released to prove the robust health of Soviet space dogs. Albina had twice flown to sub-orbital heights, but was still able to raise a family.

left: **Postcard, USSR** (1959)
A photograph showing the hall of Soviet satellites from The Exhibition of the Achievements of the National Economy of the USSR (VDNKh). This was a permanent site with a number of pavilions that, as well as staging international conferences and exhibitions, regularly showcased the technologies and products produced by the progressive Soviet society. Photograph by D. Sholomovicha.

of the leading scientists in charge of the space dog programme, suggested Malkin visit a circus to observe the famous monkey handler Capellini, and question him in detail about the species. He discovered that working with monkeys demanded far more time than with other animals. They required intense training, as well as numerous vaccines to prevent disease. In addition they were emotionally unstable and fidgety. On leaving the circus Malkin recalled Gazenko declaring that 'the Americans are welcome to their flying monkeys; we're more partial to dogs.'

Monkeys became the foundation of the American space programme, and they did prove considerably more difficult to handle. It was necessary to sedate them before flights, and many died after returning to Earth. Perhaps the animals in Pierre

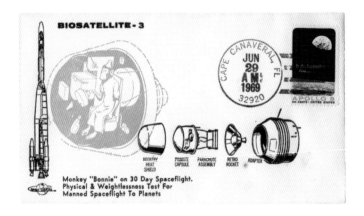

BIOSATELLITE-3

Monkey "Bonnie" on 30 Day Spaceflight.
Physical & Weightlessness Test For
Manned Spaceflight To Planets

above: **Envelope, USA** (1969)
An envelope commemorating the flight of the space monkey Bonnie. Intended to last 30 days the flight was cut short due to the illness of the passenger. He died within a day of returning to earth.

right: **Planet of the Apes, USSR** (1991)
A first Russian edition of the book by Pierre Boulle, originally published in 1963.

Boulle's book *Planet of the Apes** (1963) exacted a unique revenge for the suffering they endured during the exploration of space for the benefit of mankind. The book describes the use of laboratory experiments undertaken by apes, to study the brain of an anaesthetised human sub-species. This research is startlingly reminiscent of that conducted on real 'space travellers', who had electrodes implanted into their brains during flights. When the macaque monkey Bonnie died in 1969, only eight hours after completing her mission, animal rights activists staged large-scale protests. As a result of this persistent public pressure, the US Congress was forced to ban the use of monkeys in the space programme. The remaining animals were placed into rest homes and received excellent care. Space apes who achieved particular regard, such as the famous squirrel monkey Miss Baker, had the honour of being buried on the grounds of the US Space and Rocket Center in Huntsville, Alabama. Visitors who come to pay their respects to the memory of this space pioneer often leave a bunch of

* In 1968 the book was made into an Oscar-winning film starring Charlton Heston.

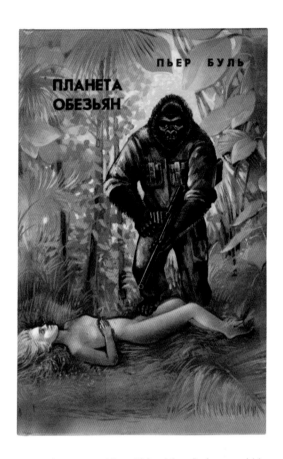

bananas on the grave. Miss Able, Miss Baker, and Ham were the three most famous monkeys in the American space programme. They were the inspiration behind Kirk DeMicco's cartoon *Space Chimps* (2008), whose protagonists include Luna, Titan, and Ham, the grandson of the first chimp that went into space in 1961, sometimes called the 'Gagarin of monkeys'.

In 1955, the Russian journalist and space flight enthusiast Nikolai Aleksandrovich Varvarov published the science fiction anthology *Earth-Moon 1974*, which described Earth's first artificial satellites – AS-1, AS-2 and AS-3 – and the first human flight to the Moon. This pseudo-documentary text mentions, among other things, that the third satellite carried monkeys into space.

Magazine illustration, USSR (c.1958)
An original ink drawing for a magazine illustration, showing the Kremlin and Sputnik 3. By the artist N. Chebotaev.

'The first automatic satellite AS-1 was followed into orbit by AS-2 and AS-3. Earth kept getting more "moons". Currently the number of satellites is into double digits. Their reports, recorded on magnetic tapes, are being studied at our Space Rocket Institute. Our institute's academic papers are devoted to a single problem. The study of the cosmos cannot fit into a single filing cabinet! How many scientific hypotheses about the Sun, light, cosmic rays, the cosmos, Earth's magnetism were buried and born thanks to the short messages from automatic satellites! How many new facts were found, how many new paths to understanding nature were discovered!

The AS-2 satellite studied various materials in low temperatures, in the shadow of the Earth, and under direct sunlight. The AS-3 satellite carried the

first living things into space: monkeys. Devices were attached to their bodies in order to measure their temperature and blood pressure, and to conduct automatic blood tests, and electrocardiograms. All of this data was sent to Earth via radio. In addition, a special television transmitter allowed us to observe the monkeys' behaviour, how they adapt to weightlessness. Of course, these first travellers have long since perished, but in their death they have saved the health, and maybe even the lives, of future astronauts. Using these animals for research has provided us with the knowledge to design the space capsule and the spacesuits of the interplanetary travellers, and helped prepare man for space flight.'

Varvarov had chosen monkeys as the champions of his fiction. In reality, top-secret launches of geodesic* rockets and their dog passengers were already being made by the USSR at the time of his writing.

* The term 'geodesic' relates to the geometry of curved surfaces. A geodesic rocket is launched straight into the air, and has its height measured from the curved surface of the Earth.

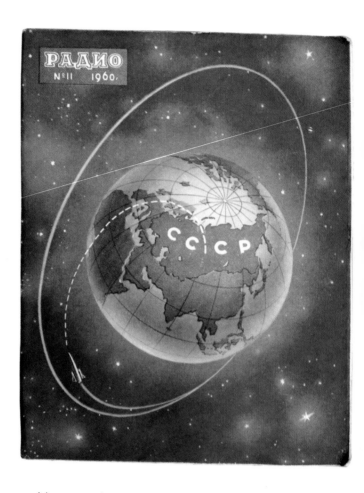

It's no accident that the space dogs are referred to as the first group of cosmonauts. Although there were radical differences between them: the human cosmonauts had volunteered, had impressive backgrounds, and considerable experience as test pilots; there were also similarities: they were both resilient, short, photogenic, and had undertaken extensive pre-flight training. Another thing they shared was the secrecy surrounding the entire programme.

In fact it was only shortly before Laika's orbital flight that documentary photos of the four-legged cosmonauts were published, alongside images showing the cabin area. The

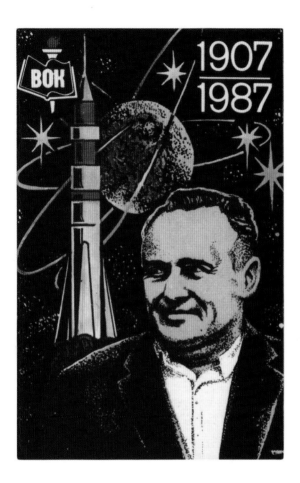

above: **Calendar, USSR** (1987)
A pocket calendar commemorating the 80th anniversary of the birth of 'The Chief Designer' Sergei Korolev.

left: *Radio* **magazine, USSR** (1960)
The cover of the magazine shows the trajectory of Sputnik 5, carrying Belka and Strelka, the first living beings to survive an orbital flight.

dogs' names, what they looked like, the tasks they performed – all this information was released gradually. The Chief Designer himself was kept a secret – his name only announced to the Soviet public after his death. This level of security was not just a vital condition for technological development during

the Cold War confrontation between the global superpowers of the USSR and the USA. In addition, from an ideological perspective, the secrecy of the space programme was justified by the notion that socialism could not be seen to fail in any of its endeavours. In this sense, space travel was the most imperative achievement of such a society. Space flight was the apotheosis of a future-facing goal.

In his novel *The Right Stuff* * (1979), which told the story of the American astronauts, Tom Wolfe emphasised this fundamental difference in approach:

> 'The Soviet programme gave off an aura of sorcery. The Soviets released practically no figures, pictures or diagrams. And no names; it was revealed only that the Soviet programme was guided by a mysterious individual known as "The Chief Designer". But his powers were indisputable. Every time the United States announced a great space experiment, the Chief Designer accomplished it first, in the most startling fashion.'

The American astronauts who were preparing for space flight were known to the whole country in advance, they gave interviews and met with the workers who built the rockets; yet Soviet cosmonauts only became real characters after they ceased to be ordinary people.

* Tom Wolfe, *The Right Stuff*, (Farrar, Straus and Giroux, New York, 1979).

Отчизна! Прогресса и мира звезду
Ты первой зажгла над землею.
Слава науке, слава труду!
Слава советскому строю!

above: **Poster, USSR** (1958)
A Sputnik propaganda poster by the artist V. Viktorov. Text reads **'Motherland!
You were the first to spark a star of peace and progress above the Earth.
Glory to science, glory to labour! Glory to the Soviet system!'**

left: **Flying toy, Japan** (date unknown)
A children's tin toy, showing 'Laika' sitting in her Sputnik.

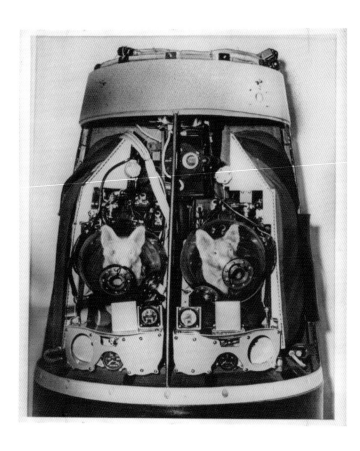

In the early stages of suborbital flights, the space dogs shared this aura of secrecy with the rest of the Soviet space programme. The flight of Dezik and Tsygan, the first dogs to go beyond Earth's atmosphere, was only made public forty years after their flight, when the information was disclosed on the deaths of many of the other canine crews during their missions. It was unthinkable that the four-legged heroes who died in these experiments might receive a stately burial. So the scientists, who were genuinely attached to their charges, were unable to mourn. But there were exceptions. In 1955, after the death of his favourite dog Lisa 2 (Fox), Aleksander Dmitriyevich Seryapin, an employee at the Institute of Aviation Medicine, defied regulations and buried her remains on the steppe,

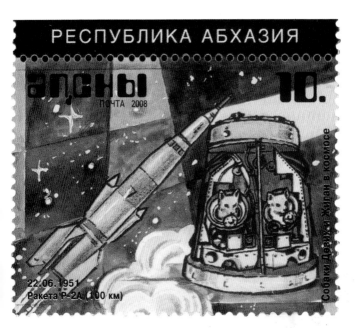

Within the stamp image:
РЕСПУБЛИКА АБХАЗИЯ
апсны
ПОЧТА 2008
10.
22.06.1951
Ракета Р-2А (100 км)
Собаки Дезик и Жиган в космосе

above: **Stamp, Abkhazia** (2008)
A tribute to the flight of Dezik and Tsygan. Text reads **'Republic of Abkhazia. Post 2008. The dogs Dezik and Tsygan in space. 22.06.1951. Rocket R-2A (100 km)'**.

left: **R-2A rocket cabin** (1959)
The cabin, with models in place of dogs, is photographed here on exhibition in Moscow's 1959 Fair for Industrial Achievement. No mission details were revealed, only that they parachuted back to Earth unharmed.

even bringing a camera to surreptitiously photograph the spot as a memento. There are many accounts of how devoted the scientists became to their charges. Even the Chief Designer, when he once found the dogs' bowls empty, sent a guard to the stockade. Before her flight, the same Chief Designer whispered into the ear of the cosmonaut Lisichka (Foxy): 'It is my deepest desire that you come back safely.' Lisichka died.

There are also many accounts of how those that worked with the dogs were sympathetic to their fate and admired their resilience. Stories have been told of how some dogs managed to outsmart their handlers and slip away before the launch, and how some record-holders were sent into space many times over. The story of suborbital flights, some successful, some

tragic, has reached us not only through first-hand recollections, but also through popular tales of 'stray dogs who became famous'. Despite the censorship of the period, these stories convey the atmosphere of affection for the animals, the attempts to make their lives comfortable despite everything, and the love, attachment and pity that was felt for them.

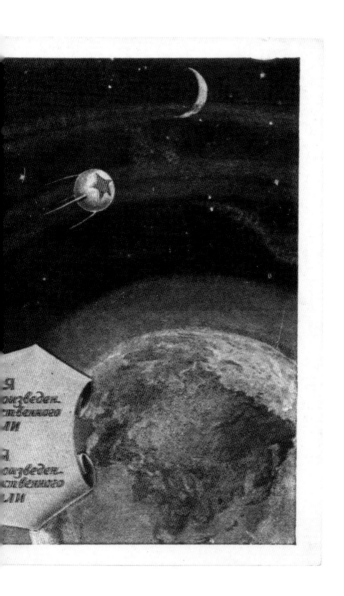

Postcard, USSR (1958)

A propaganda postcard showing Sputniks 1 and 2 orbiting the Earth. Text reads '**1957. 4 October the Soviet Union produced and launched the First artificial Earth Satellite. 3 November the Soviet Union produced and launched the Second artificial Earth Satellite**'.

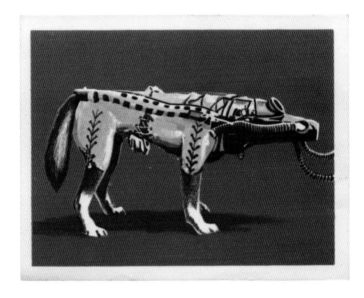

above: **Jacques Chocolate Card *Assault on the Stars*, Belgium** (1964)
The text on the reverse (in French and Dutch) explains how dog astronauts helped man explore the physical effects of space flight.

right: **Pressure suit training** (1959)
A press photograph of an unknown dog in a pressure suit. These suits (complete with acrylic glass helmets) were used to protect the dogs in unpressurised cabins during flight.

Suborbital flights involved practising take-offs and landings, testing the effects of increased gravitational load, and brief weightlessness. The 'future space scouts', as they were later called in both official propaganda and children's tales, were caught in Moscow's alleyways. Soldiers and doctors selected strays that were no heavier than six kilograms and no taller than thirty-five centimetres. Those were the dimensions of the rocket's nosecone, where the four-legged crew were installed during their missions. Lyudmila Radkevich, an assistant at the Institute of Aviation Medicine, recalled running around wastelands on the outskirts of Moscow with a tape measure, trying to work out if this or that dog would be suitable for the trip into space. Strays were not chosen for ideological reasons

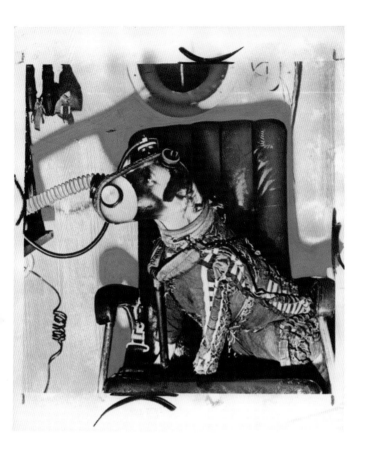

of class, but because, having to fend for themselves, it was assumed that they were naturally hardier than purebred dogs.*

On 22 July 1951, ten minutes before dawn, a geophysical rocket was launched from the Kapustin Yar† cosmodrome, reaching an altitude of 100 kilometres. On board were two canine passengers: Dezik and Tsygan (Gypsy). The nosecone containing the dogs separated correctly, parachuting down close to the launch pad some fifteen minutes later. The medical

* However, ideological reasons were a factor in choosing the first man in space. Both Yuri Gagarin and German Titov fitted the criteria, but Gagarin had peasant roots and Titov an intellectual background. According to Khrushchev Titov's name also sounded too German.
† Kapustin Yar, in the Astrakhan Region of Russia, was established as a rocket launching site in 1946, becoming a cosmodrome (a site for orbital and interplanetary launches) in 1966. For a time during the Soviet period it was a closed area, due to the classified work undertaken there.

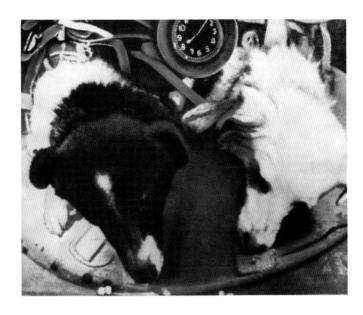

programme was run by Vladimir Ivanovich Yazdovsky, who personally fitted the dogs into the capsule before take-off. According to his memoirs, immediately on landing the waiting crowd ran towards the space travellers, even though it was forbidden, shouting 'They're alive! Alive! They're barking!' Sergey Pavlovich Korolev grabbed one of the dogs into his arms and ran around the capsule with joy, he then personally drove the heroes back to their enclosure in his car. A week later, Dezik, who was sent into the stratosphere with another partner, Lisa (Fox), died in a crash when a parachute failed to deploy.

Immediately after this tragedy, Tsygan was taken home as a pet by the academician Anatoli Arkadyevich Blagonravov, chairman of the State Committee. Blagonravov, who was a Lieutenant General of the artillery forces, could have been a real-life version of Jules Verne's Barbicane, president of the Gun Club. He devoted his entire life to artillery, and in 1963 he became the chairman of the Committee on the Exploration and Use of the Cosmos at the Academy of Sciences of the USSR. Tsygan lived out his days in the general's house, enjoying a state pension, and his puppies were given away as special rewards.

above: **Matchbox label, USSR** (1959)
A matchbox from the Borisovsky Works, showing a space dog flying to the Moon.

left: **In flight photograph** (1958)
A photograph of Belyanka and Pestraya taken by a cabin-mounted automatic camera during their successful flight of 27 August 1958. The chronometer shows 08:08 am, a few minutes after launch. The rocket reached a height of 450 kilometres.

It's rumoured that he once bit the leg of a general, who didn't dare to kick the dog in retaliation, remembering his achievements in space. Blagonravov also adopted the puppy named ZIB – the dog flown in place of Bobik, who managed to escape the evening before the mission. To avoid cancelling

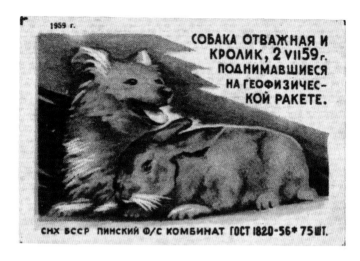

1959 г.

СОБАКА ОТВАЖНАЯ И КРОЛИК, 2 VII 59 г. ПОДНИМАВШИЕСЯ НА ГЕОФИЗИЧЕС-КОЙ РАКЕТЕ.

СНХ БССР ПИНСКИЙ Ф/С КОМБИНАТ ГОСТ 1820-56* 75 ШТ.

above: **Matchbox label, USSR** (1959)
Commemorating one of the flights of Otvazhnaya (Brave). The text reads '**The dog Brave and a rabbit, flown in the geophysical rocket 2.VII.59**'.

right: **Handkerchief, USA** (c.1957)
A printed illustration of dogs in rockets and flying saucers.

the flight, the scientists picked up another stray near the soldiers' mess hall and sent him up in the geodesic rocket instead. ZIB was a purely functional name, the initials standing for *Zamena Ischeznuvshevo Bobik* – Replacement for the Disappeared Bobik.

It is estimated that between July 1951 and November 1960 over thirty suborbital flights were launched (the precise figure is still unknown). In all, of the dogs who participated in those flights, at least fifteen died. The canine crews consisted of two dogs. This was a precaution in case one of the dogs displayed a non-typical, unusual reaction. Some of these dogs made multiple flights on geophysical rockets. The dog Otvazhnaya (Brave) earned her name after her fourth mission. She survived many flights, and became the main hero in the story *Tyapa, Borka and the Rocket* by Marta Baranova and Yevgeny Veltisov, first published in 1962 and re-printed many times since. The story incorporates lots of real-life details, including the actual names of the dogs, and the conditions they endured in tests

that prepared them for their flights. The story begins with the boy Borka going to a cinema to see a science-fiction movie called *Rena in Space*, about a monkey who had been launched into the cosmos. In an attempt to replicate the film, Borka tries to launch his dog Tyapa into space using a home-made rocket fashioned from a water pipe. But the experiment fails and the dog, frightened for her life, runs away. Eventually Tyapa ends up at the institute where stray dogs are prepared for space flight. After the hardship she suffered on the streets, she is initially given a new name – Kusachka (Biter) by the scientists at the lab. The following excerpt from the story shows how the fictional space doctor Vasily Vasilyevich Yolkin explains why they use dogs, rather than frogs or apes, for their tests:

> 'I think there are many reasons for this: because their organism is similar to our human one, because they are quick to adapt and trust, because they are calm during tests and don't get nervous. And how

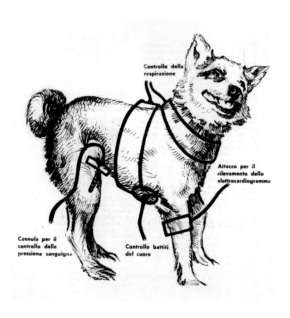

often [...] have dogs helped humans out of trouble? In hunting, at war, in clinics. They are always the scouts. And now they are the same in space.'

Kusachka, who later becomes Otvazhnaya, as well as Albina (Whitey), Kozyavka (Little Gnat), Malyok (Small Fry), Malyshka (Baby), Palma (Palm) – all names of real dogs who participated in the actual space programme – go through a series of tests involving noise and restricted movement. Then the professor announces that the future space scouts will face five dangers.

> 'One: vibration while the engine is operating; two: the powerful force of thrust during the rocket's launch and deceleration; three: weightlessness during free flight; four: lack of atmosphere at high altitude; and finally: dangerous space radiation. The cosmonauts have five invisible enemies, and it is imperative that we find out exactly how their bodies will be affected.'

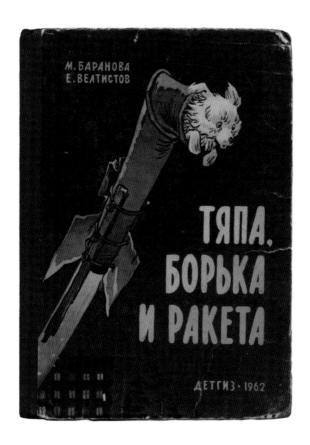

above: **Book cover: *Tyapa, Borka and the Rocket*, USSR** (1962)
The cover of the famous book by Marta Baranova and Yevgeny Veltisov, about a boy whose dog becomes a famous 'space scout'.

left: ***Oltre il Cielo* magazine: Italy** (1957)
Drawing showing how the dogs vital signs were checked in flight. Text reads (clockwise from top) '**Breathing control**'; '**Electrocardiogram connecting point**'; '**Heart monitor**'; '**Tube for monitoring blood pressure**'.

In their documentary story, Veltisov and Baranova report how the dogs are sewn into special suits with devices attached to measure their vital signs, how they're strapped to a vibrating machine that tests their resilience, and then how they are placed in a centrifuge to experience massive increases in gravitational forces. Kusachka, Palma and Malchik (Boy) are even flown in a plane. Finally, the tests are over, and following

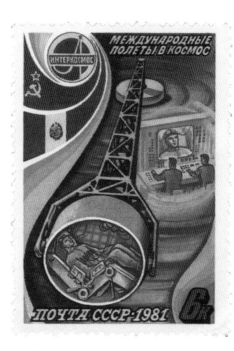

above: **Stamp, USSR** (1981)
A stamp showing cosmonauts training in a centrifuge, as pioneered by space dogs.
Text reads '**International flights in space. USSR Post – 1981. 6 kopecks**'.

right: ***Tyapa, Borka and the Rocket*, USSR** (1962)
The dogs in the story are trained on their version of the centrifuge.

thorough preparations, Kusachka and Palma are sent into space on a missile. Indeed, on 2 August 1958, their real-life namesakes did take a flight in a geodesic rocket, repeating the feat eleven days later, on 13 August. Veltisov and Baranova's tale describes how the dogs withstand increased gravitational loads, and how they return to Earth safely, where they are welcomed by elated scientists.

> 'All hail the brave and courageous scouts, is what the people flying to the Moon and Mars will eventually say. Thank you, four-legged astronauts! You went up in rockets in the days before the world had its first satellite. By risking your lives, you tested the strength of the cabins and suits; bore

НОВЫЕ НЕПРИЯТНОСТИ

Валя заглянула в круглый зал. Посреди зала стояла машина, точь-в-точь карусель: столб с подпорками, на столбе — рама, на раме — две кабины. Эта машина должна была знакомить собак с новой опасностью. Стоило карусели завертеться, как на ее пассажиров наваливались могучие, невидимые силы, бороться с которыми было бесполезно.

Сейчас машина не работала. Врач Дронов и его помощница Зина, Валина подруга, ходили по залу и о чем-то спорили. Увидев Валю, Дронов крикнул:

— Заходи!

Валя пришла поговорить о своих питомцах, но, покосившись на карусель, поежилась и неожиданно для себя сказала:

— Хорошо, что у такой страшной машины такой добрый хозяин!

— Это я — добрый? — удивился Дронов, а маленькие глаза его превратились в черные точки и весело заблестели. — Зина, — он повернулся к помощнице, — скажите, разве я добрый?

— И совсем не добрый, — ответила, нахмурив брови, Зина. — На работу опаздывать не разрешает. Сам приходит раньше, и я должна бежать. И сегодня чуть не попала под автобус. Это раз. Вчера закрывала форточку и свалилась с лестницы — два...

— В-третьих, — продолжил тем же тоном Дронов, — позавчера под моим

46

the impact of treacherous forces; entrusted yourself to the mysterious silence of weightlessness that feels like a fairy tale or a dream; and sometimes, after landing, you've spent a long time waiting for a helicopter to find you. Then it started all over again: training – flight – training. Your every

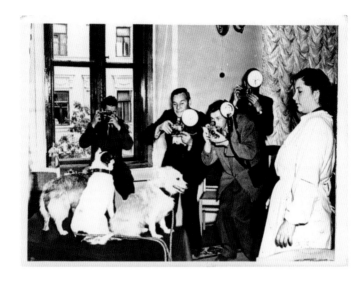

above: **Press conference, USSR** (1957)
The Moscow press conference for Malyshka, Linda and Kozyavka.

right: **Spacesuit test, USSR** (1957)
A staged photograph of a dog wearing her spacesuit and helmet.

> heartbeat is recorded in the big, vital book of
> space medicine. Those records allowed scientists
> to develop the laws of safe flight and hand them
> to the cosmonauts. Thank you!'

This is what the space doctor Yolkin contemplates on his
return from the launch pad to the institute...

The story *Tyapa, Borka and the Rocket* goes on to tell how
a documentary film is made about Otvazhnaya and Palma,
which is shown on television. The boy Borka sees it and
recognises Otvazhnaya as his old dog Tyapa. Sneaking into
the institute, he finds Tyapa, and eventually gets official
permission to visit the four-legged cosmonaut. Of course this
could only happen in a story, given the top-secret status of the
programme in reality. It seems surprising that Veltisov and
Baranova are able to divulge so many real details, but in fact
the events of this popular story take place after the flight of

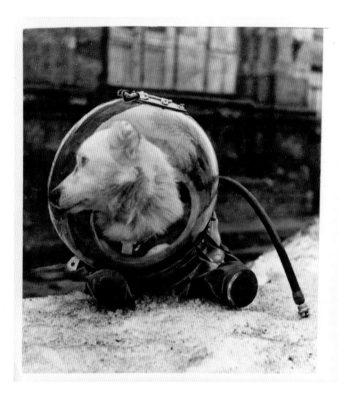

Laika, when the dog space programme was not only partially disclosed, but actively used in ideological propaganda.

Kozyavka, Linda and Malyshka were the first dogs' names to be declassified, and were announced to the public in June 1957. At the same time the USSR was preparing for the launch of the first artificial satellite, as part of the International Year of Geophysics. In the 2 July 1957 issue of *Komsomolskaya Pravda* newspaper, the correspondent V. Petrov describes the event as follows:

> 'Their names are Linda, Malyshka and Kozyavka. What a colossal success they were with Soviet and foreign photo journalists at the press conference on 18 June 1957! No wonder! They had been right up to the edge of space, an altitude of

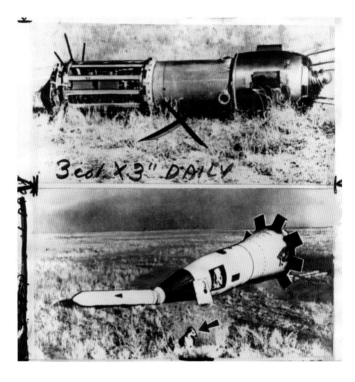

above: **'Rescue' photographs** (1958)
These propaganda photographs show the staged recovery of two unnamed dogs, who were reported by the Soviet authorities to have successfully flown to a height of 212 kilometres.

right: **Confectionery tin, USSR** (1957)
A tin bearing the image of Laika. Text reads '**Laika**'.

110 kilometres above the surface of the Earth, moving at a speed of over 4000 kilometres per hour, experiencing acceleration 5.5 times faster than that possible on Earth. They can rightly be regarded as the first space travellers.

These launches were necessary so that we can understand the effects of high-altitude rocket flight on living organisms. For the complete duration of the trip, the temperature, pulse, blood pressure, and breathing of the dogs was carefully monitored by automatic devices. While the rocket's engine

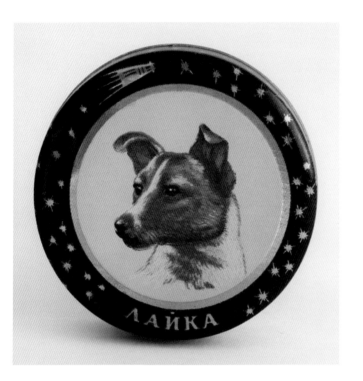

ЛАЙКА

was operational, their pulse and breathing altered slightly, due to the general overload affecting their bodies. Then, once the engine had shut off, their condition returned to normal.

They made their way back to their Motherland, back down to Earth, by parachute, from out of the heavens beyond the clouds. While the ascent lasted only a few minutes, the descent would often take as much as an hour. Throughout this time, the dogs experienced all the effects of outer space. That is why the correspondents used hundreds of metres of film, photographing their surprised faces!'

But it was only after the first orbital flight by a living being that a four-legged cosmonaut experienced true fame: when Laika became the most famous dog in history. Unfortunately, however, her fame came posthumously.

спасибо вам, четверо ногие астронавты!

Matchbox label, USSR (1966)
Text above reads **'Thank you, four-legged astronauts'**. A quote from the book
Tyapa, Borka and the Rocket (1962), by Marta Baranova and Yevgeny Veltisov.
Image from matchbox label (1966) showing Laika in Sputnik 2. Text reads **'3.11.1957
2nd Sputnik. 12 April – Cosmonautics Day'**.

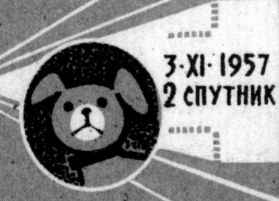

3·XI·1957
2 СПУТНИК

12 АПРЕЛЯ - ДЕНЬ КОСМОНАВТИКИ

The Heart of Laika

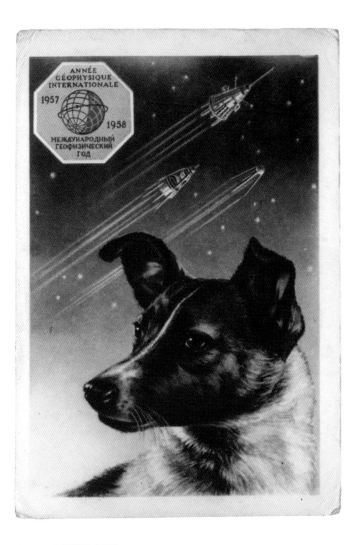

Postcard, USSR (1958)
A portrait of Laika by the artist E. Gundobin, with the first three Sputniks in the background. Text reads '**International Geophysical Year 1957–1958**'.

Laika's tragic death, her self-sacrifice in the name of the new space religion (even though no one had asked her consent), and the very image of a defenceless little dog courageously zooming into the unknown, all contributed to her becoming the first icon of space exploration. The dog's valiant little face with

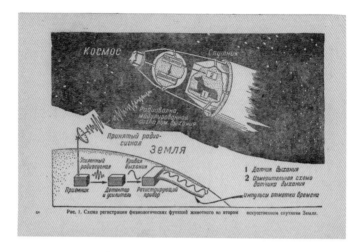

Рис. 1. Схема регистрации физиологических функций животного на втором искусственном спутнике Земли.

its pointy ears appeared on the front page of every newspaper around the world. Her poignant image came to symbolise both heroism and the undying human capacity for compassion.

Laika's biography, beatified under Soviet ideology, is short, impactful and quite human. Nothing is known of her origins, parents, or early years. As with every member of the future 'space brigade', Laika was a stray picked up in a Moscow *dvor* (courtyard). During pre-flight training, she demonstrated an exceptional capacity for endurance and tolerance. These admirable characteristics would condemn her to a martyr-like death for the benefit of the human race.

On 3 November 1957 the Telegraph Agency of the Soviet Union (TASS) reported the successful launch of the second man-made Earth satellite (the report was actually submitted to the press before the launch had happened: an indication of the authorities' aversion to failure, and the propaganda benefit of a robust space programme). Remarkably the canonisation of Laika did not happen immediately. Initially the dog's presence on board was only cursorily mentioned in a list of items citing an 'airtight container with an experimental animal (canine), air conditioning system, food supply, and research equipment for studying life functions in the conditions of outer space'. But the fact that the first warm-blooded being

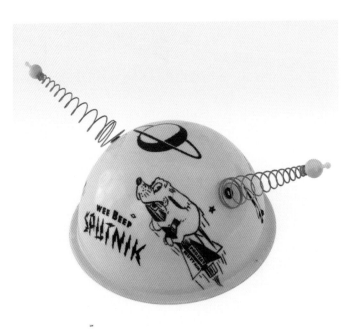

above: '**Wee Beep Sputnik**' hat, **USA** (1957)
'Wee Beep' refers to the sound emitted by the first Sputnik, which could be heard
by anyone with a short-wave radio. Visible from the Earth through a telescope, it
prompted a wave of Sputnik mania, its success reversing the perception of the
USSR as a backward country. With its sprung antennas and space dog theme,
this hat was intended for younger astronomers. '**Project Muttnik**' (written on the
rocket the dog is clinging to) was the slang term used by the Americans for the
Russian space dog programme.

left: Diagram from *The Problems of Spaceflight* by **P.K. Isakov, USSR** (1957)
Text under the drawing reads '**Diagram of the registration of the physiological
functions of the animal in the second artificial Earth satellite**'. Text in the
sky of the diagram reads '**SPACE**'; '**Sputnik**'; inside Sputnik 2: '**Modulator**';
Transmitter'; key reads: '**1. Breathing sensor**'; '**2. Breathing sensor
measurement setup**'; under Sputnik 2: '**Radio wave signal modulated by
breathing**'; in bottom half of diagram: '**EARTH**'; '**Received radio signal**';
'**Receiver**'; '**Amplified radio signal**'; '**Detector and amplifier**'; '**Breathing
curve**'; '**Recording device**'; '**Indications denote time**'.

had entered Earth's orbit caused an extraordinary sensation
across the world. Even though the dog's name was not initially
mentioned, the Americans had dubbed her *Muttnik* (in a witty
and derogatory fashion), in reference to her lack of pedigree,
and as a pun on Sputnik. The Soviet Ambassador to Great

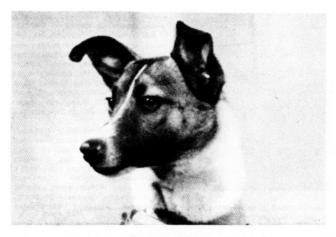

Первый путешественник в космос собака Лайка, находящаяся в кабине второго искусственного спутника Земли.
Фото Н. Филиппова

above: ***Pravda*** **newspaper, USSR** (1957)
Text reads '**The dog Laika, the first being in space, situated in the cabin of the second Earth Sputnik. Photo H. Filippova.**'

right top: **Press photograph, USSR** (1957)
This photograph of Laika has become the iconic image of the dog, being adapted for reproduction across a range of items.

right bottom: **Press photograph, USSR** (1957)
A rarer image of Laika from a series of official press photographs.

Britain said that the dog's name was Limonchik (Little Lemon). Only the following day did the name Laika appear in the Soviet press. From then on, this name became a proper name. The ordinary Russian word *sputnik* (companion) in the early twentieth century came to denote an artificial body orbiting a planet (it is believed that the term was first used by the artist Kazimir Malevich). So, after Laika's launch the Russian name for the husky breed, laika, became the name of a single dog – the dog who had travelled to outer space. In fact Laika was a mongrel, and her name was derived from the word *laiat* (to bark). Laika – 'Barker'* quickly became an inseparable attribute of the space theme heavily favoured in Soviet

* Laika was originally named Kudryavka – 'Little Curly', possibly in reference to her curly tail.

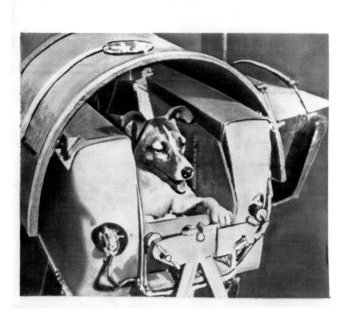

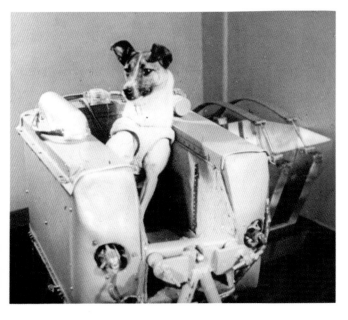

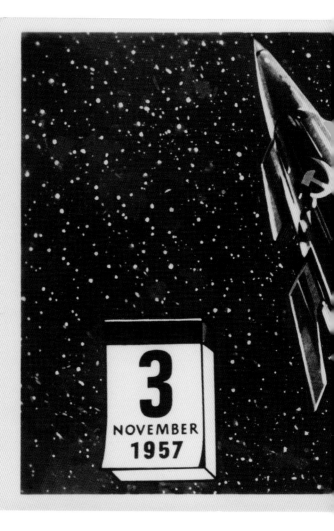

propaganda of the period. In terms of fame and the frequency that her name is mentioned, a parallel can be drawn between Laika and Yuri Gagarin. Quite simply, without the first dog in space there would be no human space flight.

Sputnik 2 was launched before the scientists had learned how to recover 'the passengers'. Although they knew from the outset that Laika would die, official reports contained no information regarding the dog's fate. However, the primary

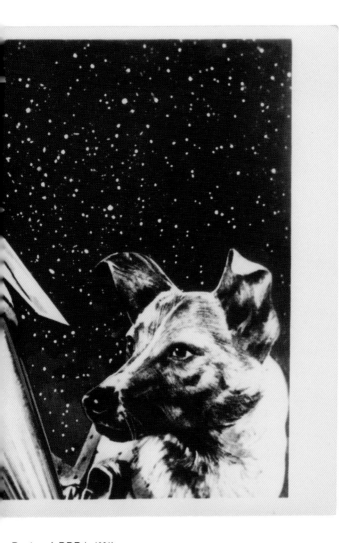

Postcard, DDR (c.1961)
A postcard from the DDR (*Deutsche Demokratische Republik*), depicting Laika and Sputnik 2 blasting into orbit.

concern of the international audience, particularly animal rights groups, was whether she would return to Earth. A British animal protection organisation even proposed to observe a moment of silence every day until Laika had landed safely. Although the USSR had already been criticised for its use of

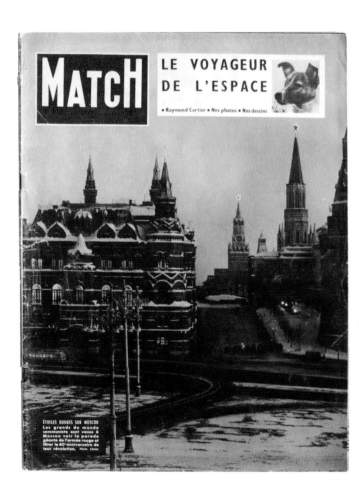

ÉTOILES ROUGES SUR MOSCOU
Les grands du monde communiste sont venus à Moscou voir la parade géante de l'armée rouge et fêter le 40ᵉ anniversaire de leur révolution. Photo Lönen.

dogs on experimental flights, this sweeping worldwide protest and concern for the dog's fate was unexpected. To counter negative reaction a special press conference immediately before Laika's launch emphasised the excellent health of the other three space dogs (Malyshka, Kozyavka, and Albina), who had already flown sub-orbital missions. The Soviet publicity machine used every opportunity to demonstrate that post-flight these dogs were still able to give birth to healthy puppies. After the initial excitement that followed the launch of Sputnik 2, they now had to explain to the rest of the world why Laika would

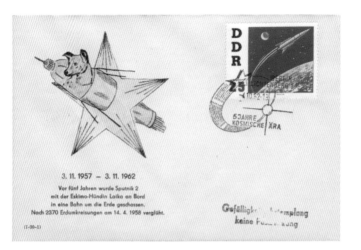

above: **Envelope, DDR** (1962)
A DDR (*Deutsche Demokratische Republik*) envelope marking the fifth anniversary of Sputnik 2. Text reads '**3.11.1957 – 3.11.1962. Five years ago Sputnik 2 was launched with the husky dog Laika aboard into an orbit around the Earth. After 2370 orbits on 14.4.1958 the satellite desintegrated.**' Text on the postmark reads '**Berlin Lichtenberg 5 years of the space age**'.

left: *Paris Match*, **France** (1957)
Cover showing a photograph of the Kremlin and the entrance to Red Square, Moscow, with an inset image of Laika. French text reads **'The Space Traveller'**.

never return. During the seven days that she was officially 'alive', newspapers would periodically publish reports on her health. After this period an announcement was made that stated she had lived in orbit for a week, during which time she had served as a source of priceless data on the plausibility of life in space; then she had been painlessly euthanased.

There were several accounts of how she had died. First: a euthanasia drug was remotely injected. Second: a euthanasia drug was administered with food. Third: by the eighth day she ran out of oxygen. In reality, due to a thermal conductivity miscalculation, Laika had suffocated just a few hours after the launch (this fact was only revealed in 2002*). The international

* At the World Space Congress of 2002, Dimitri Malashenkov (of the Institute for Biological Problems in Moscow) presented new telemetry evidence from Sputnik 2. Transmission of data had failed after five hours, but Laika's heartbeat was already faint. It is estimated that she survived up to seven hours, then died from overheating and stress.

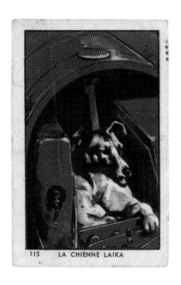

115 LA CHIENNE LAIKA

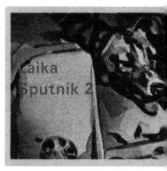

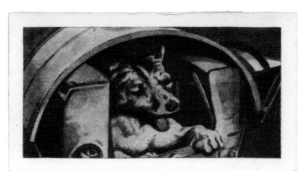

top: **Chocolate confectionery card, France** (date unknown)
Collectable card from the series *Interplanetary Travel*. Text on reverse reads **'On 3 November 1957, the second Soviet Sputnik, carrying the dog Laika, began to orbit the Earth. Millions of people followed this wonderful experiment, concerned about the fate of the small dog.'**

centre: **Matchbox, Switzerland** (date unknown)

bottom: **Mills cigarette card, Great Britain** (date unknown)
Collectable card from the series *Into Space*. Text on reverse reads **'The story of Laika, the dog sent up in Sputnik 2 by the Russians, caused considerable controversy among dog lovers. It would seem however, that as far as possible the dog was provided for on its long journey at 18,000 miles per hour round the earth. Much valuable data was collected.'**

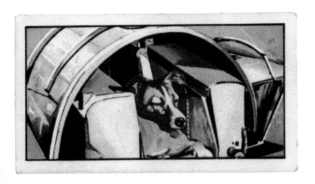

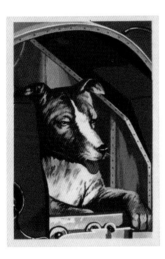

top: **Primrose confectionery cigarette card, Great Britain** (1968)
Collectable card from the series *Space Patrol*. Text on reverse reads **'A husky travelled into space in the Russian satellite Sputnik 2 on 3 November 1957. Instrument reading of heart and blood pressure and other data received were telemetered back to earth. The information was a tremendous help to physiologists in their work on problems of cosmic flight.'**

above left: **Ondina Lemonade card, Spain** (1981)
Collectable card from the series *Your best friend, the dog*. Text on reverse reads **'On 3 November 1957 a cosmonaut dog was launched into space in Sputnik 2. Although the artificial satellite stayed in space for 5 months 11 days, the dog Laika was made to commit "suicide" by eating a poison capsule.'**

above right: **Gordons Potato Chips 'Space coin', Canada** (1965)

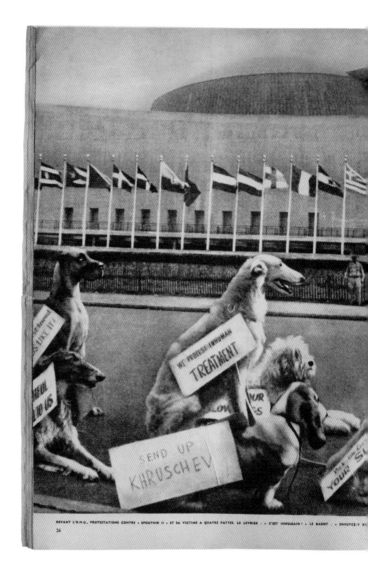

DEVANT L'O.N.U., PROTESTATIONS CONTRE « SPOUTNIK II » ET SA VICTIME A QUATRE PATTES. LE LEVRIER : « C'EST INHUMAIN ! » LE BASSET : « ENVOYEZ-Y K...

24

press accused the Soviet totalitarian regime of inhumanity, and suggested that General Secretary Khrushchev should have been sent into orbit instead. In response, the Soviet press wrote about the hypocrisy of capitalist morality, the exploitation of entire nations in the colonies, and racism. In his book *Trečioji dolerio pusė* (*The Third Side of a Dollar*, 1964), Albertas

above: **Matchbox, Italy** (c.1960)
Italian text reads **'The dog Laika'**.

left: ***Paris Match*** **magazine, France** (1957)
A page from the issue featuring Laika. This photograph shows dogs 'protesting' against her being sent into space. The French caption reads **'In front of the United Nations, protests against – Sputnik 2 – and its four-legged victim. Miss greyhound: "This is inhumane!", the basset: "Send up Khrushchev!"'**

Laurinčiukas, an American correspondent for the newspaper *Selskaia Zhizn* (*Country Life*), mentions the following anecdote. In the aftermath of Laika's launch the United Nations received a letter from a group of women in the state of Mississippi, who condemned the inhumane treatment of dogs in the USSR, suggesting that if it were absolutely necessary to send a living being into space, why not send a group of Negro children, (of whom there were plenty in their town), rather than a poor dog. It's hard to imagine that such a letter ever really existed, but the USSR's official anti-racism policy was a strong weapon in the Cold War against the USA. Regardless of these arguments, Soviet ideology was faced with a serious dilemma. Since denying Laika's death was impossible, their only viable option was to immortalise her.

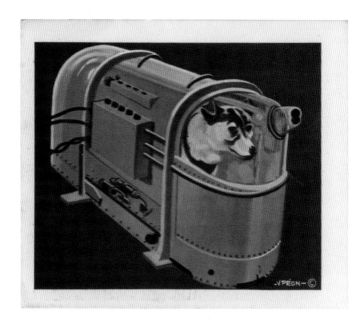

above: **Tea card, Portugal** (date unknown)

right: **Press photograph, France** (1958)
The unveiling of the first monument to Laika, built in Paris. French text reads
'To Little Curly, to her equals. Sacrificed for science, without burial'.

Empathy for this small, lovable, 'fuzziest, loneliest, unhappiest dog in the world' (*The Times*, London, 5 November 1957), laid the foundation for the overwhelming global admiration of Laika. Gradually, the perceptions of the Cold War and the opposition between socialist and capitalist systems will begin to fade from our memory; eventually the acronym 'USSR' will become a mystery; yet most people on Earth will still be able to recall Laika's name and image.

The first memorial to Laika was built in Paris in 1958. A granite column was erected in front of the Paris Society for the Protection of Dogs, to commemorate the animals who had given their lives in the name of science. The dedication reads: 'For the first living being to reach outer space'. Crowning the column is a figure of Laika peering out of Sputnik 1. In Japan, Laika's image became the symbol for the Year of the Dog in

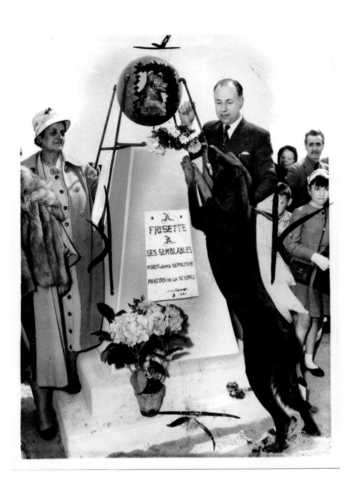

1958, which led to the manufacture of great quantities of Laika souvenirs. The Finnish rock group 'Laika and the Cosmonauts' was formed in 1990, followed by the emergence of a British band 'Laika' in 1993. Only in 2008, for the 50th anniversary of Laika's flight into space, was a monument erected to her in Moscow. Located in the courtyard of the Institute of Aviation Medicine, it was constructed following a petition by scientists to preserve the memory of the four-legged cosmonaut. Artistically, this monument can hardly be called a success, although those who knew Laika say that the life-sized sculpture bears a strong resemblance. The small dog, its face lifted

above: **Menko playing cards, Japan** (1958)
Text on the cards (clockwise from top left) reads **'Laika'**; **'Laika, the man-made satellite dog'**; **'Space dog, man-made satellite'**; **'Space Dog Laika'**.

right: **Menko playing card, Japan** (1958)
Text reads **'Space Dog'**.

skywards, is standing on top of a rocket in the shape of a giant open hand. Importantly it recognises that the dog was a sacrifice made for and by humans.

The canonisation of Laika unfolded following a perfectly human script. Granted, she did not begin to speak, or perform posthumous miracles, nevertheless, those few hours (or, according to the official version, the week) that Laika lasted in the airtight capsule of Sputnik 2, and (paradoxically) her

death, became living proof of the miracles performed by Soviet science and technology. The fact that Laika survived g-forces during launch, entry to orbit, microgravity, and those few times she had circled the Earth, provided a tangible context for sending man into space. Consequently Laika deserved to have been named the first cosmonaut. In addition, her sacrifice was perfectly in line with Soviet ideology. In the USSR, where official propaganda had attempted to replace religion with science,* sacrifice in the pursuit of scientific knowledge was considered normal. In literature and film, scientists would risk

* The Soviets had attempted to use their scientific progress to 'educate' the masses to believe in the power of science over religion. Where churches weren't destroyed by the authorities, the inside of their domes were often repainted as astronomical star maps. During his flight, Gagarin was reported to have said 'I don't see any God up here', but these words were later attributed to Khrushchev and his anti-religion campaign.

above: **Laika clockwork satellite toy, West Germany** (1958–1965)
A toy made by the GNK company between the dates shown above.

right: **Laika cigarettes, USSR** (1958)

their lives for the higher purpose without a second thought. This clichéd notion that everyone must be ready to die for their Motherland was naturally projected onto Laika. Precisely because of this, it is conceivable that Soviet mass media found itself unprepared for the worldwide concern over the dog's fate, and the outrage resulting from her death. From the Soviet perspective this was a straightforward act of heroism attributed to a dumb creature, whereas the West saw the event as a synonym for a pitiless and cruel ideology.

The adoption of Laika as a hero, and the fact that she was so photogenic, led to increased publication of her image in the pages of magazines and newspapers. She also began to appear on badges, stamps, cards, matchboxes – even cigarette packets. Java, a Moscow tobacco factory, had quickly introduced production of a filtered cigarette brand

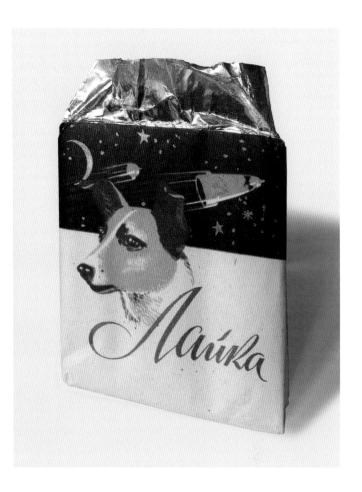

named 'Laika', while another factory in Leningrad followed with an unfiltered version. The packet for these cigarettes depicted Laika against a backdrop of the (easily recognisable) first two Soviet satellites, flying across a deep blue starry sky in an elliptical orbit. She was portrayed in a three-quarter view, with her face – definitely appearing more mature than in photographs and film footage – turned in the opposite direction to the trajectory of the satellites. The design was very successful. The fact that she was looking the other way symbolised that, although both satellites had burned up in the atmosphere, Laika's image would live forever in people's memory.

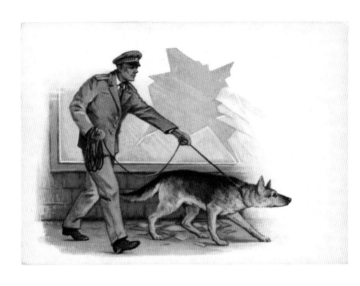

above: **Postcard, USSR** (1972)
A postcard by the artist L. Aristov, from the collection titled: **'Friends of Man'**. It depicts a German shepherd – the most common dog used by the Soviet authorities – in action. The caption on the reverse reads **'Tracking'**.

right: **Porcelain figurine, USSR** (1950s)
The *Young Pioneer with a German Shepherd* figurine, by G. Stolbova, made at the Lomonosov Porcelain Factory, Leningrad.

Before 'Laika' cigarettes emerged, there was already an extremely popular cigarette brand called 'Drug' (Friend). Its packet carried an image of a dog, an unnamed German shepherd. A dog could easily be a man's best friend, but with Soviet logic, first and foremost any dog would have to be a useful member of society, just like man. For example, the book mentioned previously: *Tyapa, Borka, and the Rocket* (1962) discusses the worthlessness of a pet poodle that fetches slippers for his owner as opposed to the serious work of four-legged cosmonauts. A poodle with slippers was considered a relic of the bourgeois treatment of dogs as useless toys. In the children's fantasy *Neznaika on the Moon* (1965), by N. Nosov, the protagonist flies in a rocket from the Communist Sun City to the Moon, which is unmistakably recognisable as America. He is stunned by the frivolous lunar customs. On the capitalist

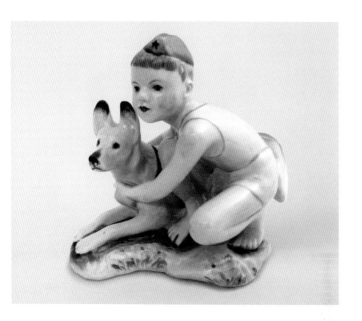

Moon 'there were special dog hair salons, and special dog shops selling all kinds of dog delicacies; dog restaurants, cafés and bakeries'.

In Soviet books and films from the 1930s to the 1960s, dogs were typically depicted performing one of two duties: either as German shepherds patrolling the borders of the USSR and apprehending trespassers, or as tactical K-9 dogs tackling the embezzlers of socialist property. In the film *Come Here, Mukhtar!* (1964) the title character is a German shepherd with a difficult past. His owners acquire him for entertainment, but he is subsequently thrown out. A police lieutenant (played by the popular Soviet actor Yuri Nikulin) then befriends Mukhtar. The dog is badly wounded catching a thief, and the film's storyline revolves around the lieutenant's fight to secure official recognition of Mukhtar's 'human' attributes as a police hero, gunned down in the line of duty. A variation on this theme is the *Young Pioneer with a German Shepherd*, immortalised as a mass-produced china figurine. The dog and its young helper, vigilantly guarding the borders of the Soviet Union, could be found in almost every home.

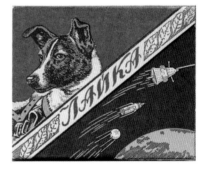

top row: **Drug (Friend) cigarettes, USSR** (c.1957); **Vimpel (Pennant) cigarettes, USSR** (c.1960)

middle row: **Sputnik cigarettes, Ukrainian SSR** (c.1958); **Kosmos (Cosmos) cigarettes, USSR** (date unknown)

bottom row: **Laika cigarettes, Bulgarian SSR** (c.1958); **Laika cigarettes, USSR** (c.1958)

top row: **Orbita (Orbit) cigarettes, Moldovian SSR** (date unknown); **Saturn cigarettes, USSR** (date unknown)

middle row: **Mezhplanetnie (Interplanetary) cigarettes, USSR** (c.1958); **Vostok (East or Orient) cigarettes, USSR** (c.1961)

bottom row: **Kosmos (Cosmos) cigarettes, Ukrainian SSR** (date unknown); **Zvezdochka cigarettes, USSR** (c.1961)

above left: **Matchbox label, USSR** (1961)
Text around the dog's head reads **'First living being in space'**. The logo top left
reads **'Moscow, 1961'** (for the 1961 Moscow International Film Festival).

above right: **Matchbox label, Estonian SSR** (1958)
Text reads **'Tallinn Match Factory. 4.X.1957, 3.XI.1957** [the launch dates of
Sputniks 1 and 2]'.

right: **Matchbox label, USSR** (1962)
Text reads **'Taking on the universe. The second Sputnik. 3.XI.1957'**.

Space imagery in the tobacco industry is a separate story,
which even outlasted the collapse of the USSR. Whereas
'Laika' cigarettes were of a fairly low standard, their unfiltered
counterpart 'Mezhplanetnie' (Interplanetary) were considered
top quality. The cigarettes 'Soyuz-Apollo' were developed in
collaboration with Phillip Morris specifically to honour the
1975 Soviet–American rendezvous in space, and became a rare
commodity. It was a commonly held notion that 'to get hold
of a packet was as likely as being able to fly into space
yourself.' They were only manufactured for five years, after
which their production didn't begin again until the 1990s.
This was also when the 'Kosmos' (Space) brand of cigarettes

became popular. After perestroika, space became a revanchist motif in advertisements for 'Java' cigarettes. Stylised images of space technology from the film *Star Wars* (1977) and the tagline 'The Empire Strikes Back' unequivocally nodded toward the title of *Episode V* (1980) of the famous cinematic space saga. At the time of its theatre release, *Star Wars Episode V: The Empire Strikes Back* (1980) perfectly mirrored the situation in the Cold War: the opposition of the Good (the West) and 'The Evil Empire' (as President Ronald Reagan would call the USSR in 1983). In the mid-1990s the 'Java' advertising campaign transposed this struggle to the tobacco industry, where the post-Soviet empire was meant to strike back at Western industry, which was taking the Russian tobacco market by force. Both filtered and unfiltered 'Laika's, alongside the unfiltered 'Belomorkanal',* were intended to testify to the achievements of the USSR, whilst not triggering any memories of its victims.

* The Belomorkanal connected the White Sea to the Baltic Sea, and was a result of Stalin's first Five Year Plan. An estimated 25,000 workers died during its construction (1931–1933). As a feat of engineering it was completely flawed: it wasn't deep enough for most shipping, and continuously silted up. Despite these faults it was still commemorated with the issuing of Belomorkanal brand papirosa (a very strong cigarette, a third of which is tobacco, the remaining two thirds is made up of a hollow cardboard tube which is pinched together when smoked).

Details of the dog's short pre-flight life at the Institute of Aviation Medicine were fictionalised in *Tyapa, Borka, and the Rocket* (1962). Here is how Laika's courageous endurance during the arduous pre-flight training is extolled:

> 'A young mongrel with thin legs, a short tail, and a naïve, dumbfounded face turned out to be the most tolerant... Nay, there was no power that could break the determination of this dog with the pointy spear-like ears!'

The story goes on to describe the search for the way to feed Laika in microgravity, the idea to bond nutrients with agar (a jelly-like substance), and of a piece of clothing specially tailored to support her in the capsule. However this children's

above: **Sputnik bank, USA** (c.1957)
A tin 'piggy bank', with a Laika-like dog gazing from the cabin. Made in Japan.

left: **Poster detail from '*The Soviet Earth Sputniks*', USSR** (1958)
An illustration by N. Dutov showing the orbits of the Sputniks around the Earth.
Text by the star reads **'Moscow'**, text by the red line reads **'Equator'**.

book fails to mention what proved to be the most tricky
obstacle: finding a way for the dogs to relieve themselves in
such unusual conditions. Although their suits had special
receptacles for urine and faeces, it was difficult to train the
dogs to use them (they prefer to relieve themselves outdoors,
never inside a room or a cockpit and certainly not inside
clothes). This process was unnatural for the dogs, only those
who took to it more easily were selected. For orbital flights,
all the dogs were exclusively female: as there was no room
in the cabin to cock their legs, they were better suited to space.

'At the factory a cylindrical capsule with a round window was built for Laika. It was equipped with control systems for monitoring the dog, an automatic feeder with a supply of delicious jelly, chemicals for generating oxygen and removing carbon dioxide, and a special passenger chair. In this 'seat' Laika, dressed in a lightweight spacesuit, could move forward and backward, sit, lie, and stand. It was like a small, tightly closed house, resembling a tin can with a round lid. In it Laika would not be frightened by the emptiness of space.'

The story tells how, on 3 November 1957, people everywhere learned about Laika and fell in love with her. How they studied her portrait in the newspapers. How the joy of having launched the first cosmonaut was mixed with the sadness of knowing that Laika would never return to Earth.

In a special programme on 5 November 1957, Moscow radio reported: 'Although we are filled with sympathy and sorrow for little Laika, at the same time we cannot divert our attention from the enormous significance of her sacrifice for scientific research.' Officially, Laika was pronounced dead on 10 November. A giant front page article in *Pravda* newspaper

above: **Cut-out 'Likka' doll, *Wee Wisdom* book, USA** (c.1957)
A paper doll space dog cut-out from a children's book. Published by Unity School of Christianity, Missouri.

left: **Matchbox label, China** (date unknown)

from 13 November included a detailed description of Sputnik 2, a portrait of Laika, and a statement that the seven days the dog had spent in orbit had provided scientists with invaluable information that would further the exploration of outer space. 'There is no doubt that the research we have been able to

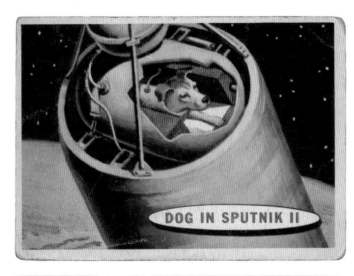

DOG IN SPUTNIK II

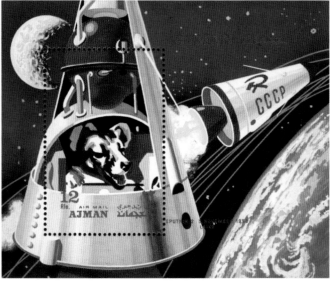

conduct will make a significant contribution to the process of exploring successful forthcoming interplanetary flights, and serve as a foundation for developing the means to ensure the safety of human space flight.' As for the satellite, it continued flying until 14 April 1958, orbiting the Earth 2570 times, before disintegrating on re-entry into Earth's atmosphere.

above: The cover of the postcard collection titled: '***Friends of Man***'. (1972)

top left: **Topps Space Card, USA** (1958)

bottom left: **Stamp, Ajman** (1971)

Perhaps the most heartrending lines of *Tyapa, Borka, and the Rocket* (1962) are reserved for the actual heart of Laika, the rhythms of which were being recorded by telemetric devices.

> 'Laika, sweet loyal Laika, how happy have you made the scientists all around the world! The faint beating of your heart, fluttering from a thousand-kilometre altitude, to them has drowned out all other sounds.
>
> And on a paper tape, data-recorders traced a pattern that looked like a city skyline, with peaks like the steeples of high-rise buildings.
>
> It was beating, beating, beating – the beating heart of a living space passenger!
>
> The paper tape would tell the doctors how the rocket engines let out a roar, and how Laika was frightened by the thunderous sound. She turned her head from side to side for some time, then an

enormous weight pressed her into the floor. Her heart beat at three times its normal speed – the carrier rocket was breaking through the atmosphere – when suddenly all became quiet, and the dog, startled, raised her head. She found herself in a still emptiness...

And although back on Earth Laika had never experienced such a strange state of lightness, she did not feel afraid. After a brief rest, she took a look around. Then her paws nimbly pushed her body away from the floor, and the cosmonaut took her first steps into weightlessness. [...]

For seven days she lived in the satellite. On the eighth it ran out of oxygen...

Back at the Institute there was an empty cage. Nailed to the cage was a sign: "Laika lived here." No one was allowed into that cage, it was a reminder that the next cosmonaut must be returned to Earth.'

This story presents a heartbreaking rendition of Laika's short life and death, which closely follows the official version. It is no coincidence that one of the co-authors, Yevgeny Veltistov, had previously worked as a newspaper reporter.

— Как вкусно пахнет ёлкой!

Что же касается Кусачки, Мальчика и Пёстрой, то они нашли, что лучше всего пахнет колбаса. И вскоре же полакомились ею. А потом, утолив голод, весело играли с Сашкой и забыли про свою поездку.

Утром Ёлкин отвёз собак в институт. Оказалось, что их клетки заняли новые бродяжки, прибывшие с ветеринарной станции. Путешественниц поместили в другой комнате, всех троих в одной небольшой клетке. Это было не совсем удобно. К тому же в комнате стояла пустая клетка.

Но Василий Васильевич не стал её открывать. Он постоял около пустой клетки молча, взглянул на знакомую табличку и вышел.

На пустой клетке была надпись: «Здесь жила Лайка».

ЗДЕСЬ ЖИЛА ЛАЙКА

Чтобы рассказать историю пустой клетки, заглянем в недалёкое прошлое, в год 1957-й.

Третье октября 1957 года было для мира обычным, будничным днём. Школьники сидели за партами. Рабочие стояли у станков. Лётчики летали быстрее звука. И никто не подозревал, ложась вечером спать, что завтра он проснётся в другой эпохе.

А утром 4-го октября весь мир был взбудоражен новостью: над Землёй ле-

66

above: **Туара, Borka and the Rocket** (1962)
An Institute worker pays his respects at Laika's empty cage. The sign reads '**Laika lived here**'.

left: **Illustration from the book To the Stars, USSR** (1990)
A drawing of Laika from a popular colouring book. Authors and artists: Z. Kutilova, I. Aidarov.

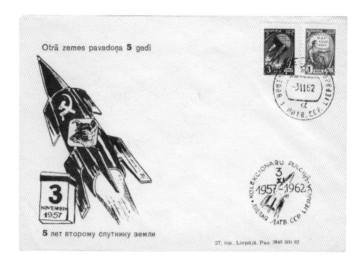

Otrā zemes pavadoņa 5 gadi

3
NOVEMBER
1957

5 лет второму спутнику земли

1957–1962

27, tip., Liepāja. Pas. 3843 500 62

In the USSR there was a popular slogan borrowed from a song: 'We have been born to make a fairy tale come true.' Here, ideology necessitated that reality be turned into a fairy tale.

The book *Pervye Stupeni: Zapiski Inzhenera* (1970), (*The First Steps: An Engineer's Notes*), written by the rocket scientist Oleg Ivanovsky, (who, because of his top-secret clearance, had to write under the pseudonym Aleksei Ivanov), is a minute-by-minute account of the day of Laika's launch and the events preceding it.

The book has been reprinted several times, and as historians have noted, comparing the editions reveals the unmistakable hand of censorship, particularly wherever the text concerns Laika. For example, the 1970 (first) edition gives very brief details about the construction of the space capsule, whilst the 1982 edition goes into much more detail mentioning that prior to the flight engineers had discovered that the thermal insulation system was not sufficient, but that it was too late to make any modifications. It was precisely this technical fault that was the reason for Laika's swift death.

Dr Vladimir Yazdovsky, who was responsible for preparing the dogs, selected Laika for the space flight ten days prior to the scheduled lift-off. She was one of the ten dogs who had

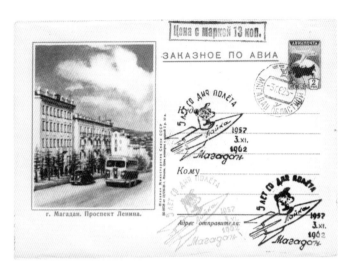

top: **Envelope** (1962)
A Magadan philately club envelope, marking the fifth anniversary of Sputnik 2. Text reads '**Price stamped 13 kopecks. Registered by air. 5 years since the date of the flight. Magadan**'.

bottom: **Envelope** (1962)
A Ukrainian philately club envelope postmarked Dniprodzerzhynsk, marking the fifth anniversary of Sputnik 2. Text reads '**5th anniversary of the launch of the second Sputnik**'.

left: **Envelope** (1962)
A Latvian philately club envelope marking the fifth anniversary of Sputnik 2. Text in Latvian and Russian reads '**5 years since the second Earth Sputnik**'.

completed the special training, from which two finalists for the space flight emerged: Albina and Laika. Albina was everyone's sweetheart, and she had already been sent on two sub-orbital flights, in addition she'd just given birth to a litter of puppies. Laika had never flown, but stood out as a result of her ability to endure the most difficult tests, and her calmness in doing so. According to the pre-flight test results, Albina should have flown; however, the decision was made to send Laika.

Postcard, USSR (1957)
A photomontage by the artist Sveshnikov with Sputniks 1 and 2. Text reads **'Happy New Year'**. Caption on the reverse reads **'The Soviet flag seen from space'**.

The total weight of Laika and the satellite was 508.3 kg. She was a striking dog, approximately two years old, light in colour but with dark brown spots on her face, which possessed a surprised expression. Crucially, her image reproduced well in black and white photographs and film footage. This was an

important factor, it was recognised that the launch would be historically significant and therefore would be meticulously recorded. Consequently, unlike the administrative photographs of the dogs used on sub-orbital flights, the documenting of Laika's flight bestowed a rich iconography. The memoirs of Dr Vladimir Yazdovsky describe this portentous moment: 'Before flying out to the cosmodrome, I once took her home and showed her to my children. They played with her. I wanted to do something nice for the dog. She didn't have much longer to live. Now, after so many years have gone by, Laika's flight seems very modest, but it was truly a historical event.'

The third dog, designated to play a technical role, was Mukha (Fly). She was subjected to the same ordeals that awaited Laika in space, in order to gauge any adverse reactions. Ivanov (aka Ivanovsky) reveals how Mukha nearly died on Earth

above: **Spinning top, Japan** (c.1958)
Made by S. I. Toys, this spinning top depicts Laika standing on a version of Sputnik 2 surrounded by a space-themed frieze.

left: **Bucket, Japan** (c.1958)
Here Laika is pictured inside Sputnik 2, which due to the lack of images of the second rocket, looks very similar to Sputnik 1.

when she was placed in an airtight capsule with only food and water for three days. On the third day all that could be seen through a viewing porthole were the dog's sad eyes. Once the testing was over and Mukha was released, the scientists could not understand how she had survived, as the food and water remained untouched. Some even joked that Mukha was upset because it had been decided that it would be Laika who was to be the first to fly into space (Mukha had short legs, so she wouldn't look so attractive in the photographs).

Laika's pre-flight preparation began on the morning of 31 October 1957. Here is how Ivanov (Ivanovsky) describes it:

> 'She calmly lay on a shiny white table while technicians cleansed her skin with a light alcohol solution and thoroughly brushed her hair. Then iodine and streptocid powder were used to sterilise the places where electrodes were implanted under her skin for ECG recordings. These procedures took two hours.
>
> At last, the "grooming" is finished. Sergei Pavlovich (Korolev), Konstantin Dmitrievich, Mikhail Stepanovich and a few others, all clad in white lab coats, enter the laboratory. Korolev thoroughly examines the animal and oversees the final preparations. Finally, at 14.00 hours, Laika is placed in the capsule.'

Reportedly, Korolev affectionately tickled Laika behind her ear. Following final checks, the capsule containing Laika was delivered to the launch site, ready to be placed into the rocket. It was 1.00 a.m. on 1 November. Ivanov goes on to tell how the medical staff managed to persuade the authorities

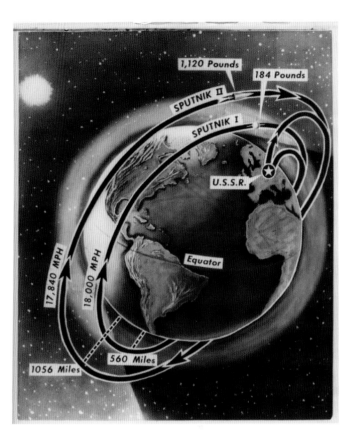

above: **Newspaper diagram, USA** (1957)
A diagram comparing the two Sputniks as they circle the Earth. Sputnik 1 completes a single orbit in 96.2 minutes, while Sputnik 2 takes 103.7 minutes.

left: **Press photograph, USSR** (1957)
A scientist uses a model globe to point out the orbit of Sputnik 2.

to momentarily unseal the airtight capsule, under the pretence of balancing out the interior cabin pressure. They were able to give Laika some water, and she 'gratefully nodded her wet nose' in response.

Due to technical problems Laika was to spend the next three days in the capsule on the launch pad. To keep her from freezing at night, Korolev ordered that the capsule had to be heated with warm air through a hose. Then, on 3 November, at

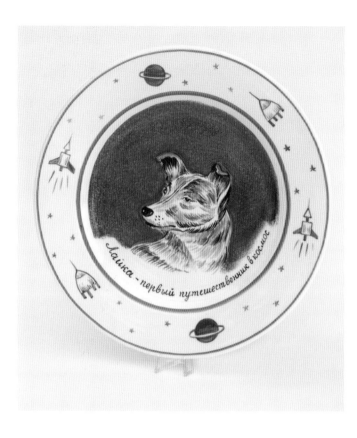

Лайка - первый путешественник в космос

5.30 a.m. Moscow time, the rocket lifted off from the new Tyuratam polygon carrying Laika into space – toward her agonising death and posthumous glory. It was from this same location four years later that Yuri Gagarin would be launched into space. The then renamed Baikonur Cosmodrome* would host over half a century of space flight: first Soviet, then international and Russian. Baikonur became the site of many successful launches. There were also a few tragedies, both at lift-off and re-entry, but no crew – human or dog – would ever again be sent to a certain death.

* The Baikonur Cosmodrome in Kazakhstan was first established as a testing centre for missiles in 1955. Originally chosen because the surrounding flat steppe allowed for uninterrupted radio signals between ground stations and rockets, the site was used for all the major Soviet launches. Today it is the world's largest operational space facility.

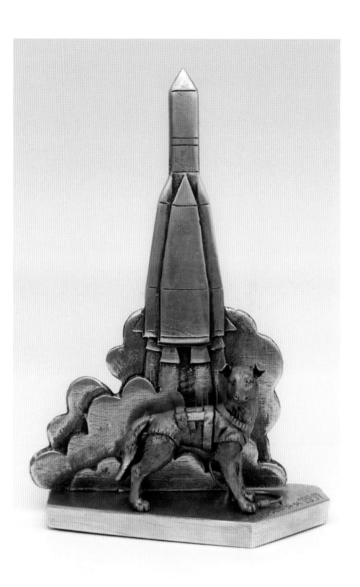

above: **Metal desktop sculpture, USSR** (c.1958)
A depiction of Laika and Sputnik 2 made by the artist Ivan Irpensky. This sculpture was made in limited numbers for the staff of the Institute of Medical and Biological Problems, Moscow.

left: **Commemorative plate, USSR** (c.1970)
Text reads '**Laika – the first living being in space**'.

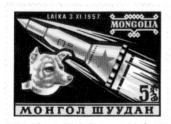

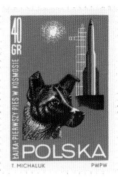

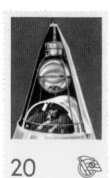

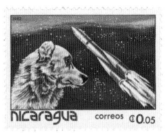

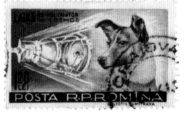

top row: **Mongolian stamp** (1963); **Polish stamp** (1964)

middle row: **DDR stamp** (1975); **Nicaraguan stamp** (1982)

bottom row: **Albanian stamp** (1962); **Romanian stamp** (1957)

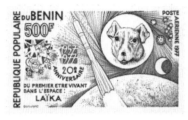
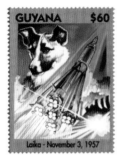
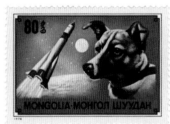
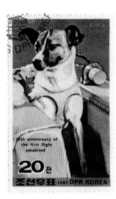
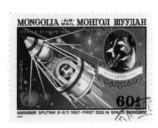

top row: **Beninian stamp** (1977); **Guyanian stamp** (1994)

middle row: **Mongolian stamp** (1978); **DPR Korean stamp** (1987)

bottom row: **Mongolian stamp** (1982); **Sharjahian stamp** (1972)

above: **Cigarette case, USSR** (c.1959)
A plated metal cigarette case showing the first three Sputniks. Text reads **'USSR'**, **'Soviet Sputnik Satellites'**.

right: **Uncut Laika confectionery wrapping sheet , Ukrainian SSR** (c.1960)
Text reads '**Laika Sweets**'.

During the launch, Laika's heart rate exceeded 260 beats per minute (three times faster than normal); the g-forces caused her respiratory rate to increase four to five times; then her heart slowed down. This information, as well as the ECG readings received at that time, allowed the doctors to determine that Laika had successfully tolerated entry into orbit. A little while later, telemetric sensors recorded that in zero-gravity Laika's vital functions had stabilised, her breathing had become slower and deeper, and her movements more controlled. Her brain and heart were working as normal. The scientists were triumphant: Laika *WAS* alive!

Unlike the signal of the first Sputnik, which was heard all over the world, the sound of Laika's heart was only heard by the Soviet scientists, and then only for the first five hours of the flight. Because of a miscalculation in the thermodynamics, the capsule was equipped with virtually useless cooling fans, and Laika died in agony from the searing temperatures.

General Secretary Nikita Sergeyevich Khrushchev had told the scientists that another space satellite needed to be launched in honour of the rapidly approaching fortieth anniversary of the Bolshevik Revolution on 7 November 1957. This meant that Sputnik 2 had been prepared in a frantic rush.

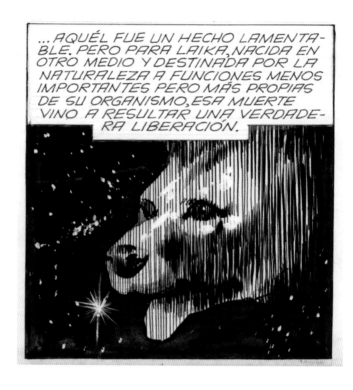

above: *La Perra Laika (Laika the Space Dog)*, **Argentina** (1960s)
Original artwork by Juan Oscar Carovini, published in *Patoruzito Semanal* (No. 79).
The Spanish text reads '(Laika died)... **That was regrettable, but for Laika, born in another medium and destined by nature to functions less significant but more of her own body, her death came to be a true liberation**'.

right: **Postcard, USSR** (1959)
The first three Sputniks and Luna 1 fly over the Moscow State University building as fireworks explode. Text reads '**Congratulations!**'

Following the sensational launch of Sputnik 1 on 4 October 1957, Khrushchev had called a meeting with the leading space theorist Mstislav Keldysh,* the founder of Soviet astronautics Konstantin Rudnev,† and the head spacecraft designer Sergei Pavlovich Korolev. Rumour has it that someone suggested the

* Mstislav Keldysh (1911-1978) was a key figure in the Soviet space programme. Known as 'The Chief Theoretician' (in reference to Korolev being known as 'The Chief Designer'), he was honoured as a Hero of Socialist Labour in 1956, 1961, and 1971.
† Konstantin Rudnev (1911-1980) was the Chairman of the State Committee for Defense Technology. He was awarded six Orders of Lenin and made a Hero of Socialist Labour in 1961.

second Sputnik played 'The Internationale' as it orbited, to which Khrushchev replied that a space satellite is not an expensive barrel organ. Then Korolev proposed sending a dog into space. Dogs had been flown on several sub-orbital flights, furthermore they were already undergoing special training at the Institute of Aviation Medicine. With the engineers literally living in the spacecraft factory, it would be possible for any technical issues to be dealt with as soon as they arose.

"THAT DOG WE PUT INTO ORBIT IS TOO DARNED CLEVER——— HE'S JUST RADIOED BACK FOR A LAMPPOST."

Construction blueprints were immediately sent to the production facility. The second Sputnik, six times the weight of the first, was prepared in less than three weeks. Formal approval of the launch was granted on 12 October. The satellite on Sputnik 2 (unlike that of Sputnik 1) was mounted on the second stage of the rocket. Because the engineers did not have enough time to develop a recovery solution, it was decided to simplify the flight process by not releasing the satellite from the rocket. This decision also played a role in

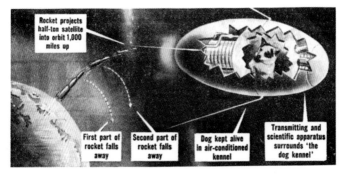

Label callouts within the illustration:
- Rocket projects half-ton satellite into orbit 1,000 miles up
- First part of rocket falls away
- Second part of rocket falls away
- Dog kept alive in air-conditioned kennel
- Transmitting and scientific apparatus surrounds 'the dog kennel'

above: **Newspaper illustration, Great Britain** (1957)
An illustration for the *Daily Express* by John Bodle. The artist impression was released before Laika's real name was known, as the accompanying text refers to her as 'Little Lemon'.

left: **Postcard, Great Britain** (c.1958)
A humorous postcard drawn by the artist 'Dudley'.

Laika's torturous death. Her capsule overheated in two ways: from the inside through the work of the engines, and from the outside through solar radiation. TASS continued posting reports about the dog's good health long after her capsule had become a scorching coffin. When the true facts of Laika's demise were admitted in 2002 (see page 89) Oleg Gazenko, who was responsible for the medical aspects of the space dog training, conceded that it was a great shame about Laika: 'Working with animals is a source of suffering to all of us. We treat them like babies who cannot speak. The more time passes, the more I'm sorry about it. We shouldn't have done it. We did not learn enough from the mission to justify the death of the dog.' According to later interviews given after perestroika, the scientists also stated that their account of Laika's death being caused by technical errors was not believed by the authorities. A special committee forced them to repeat the experiment on the ground, killing two more dogs in the process.

Mikhail Bulgakov's *The Heart of a Dog* (1925) could be read as a fictional presage to the Soviets' use of dogs for experimental purposes. The protagonist, a certain Professor Preobrazhensky, accidently turns a dog named Sharik into a man. The clever stray, who had even learned the alphabet by

above: **Laika clockwork toy packaging, West Germany** (1958–1965)
A toy made by the GNK company between the dates shown above.

top right: **Envelope** (1962)
An envelope from the Baku philately club in Azerbaijan. Text reads '**Five years since the launch of the Second Earth Satellite. Baku Gok**'.

bottom right: **Envelope, USSR** (1974)
An envelope with an image of Laika marking Cosmonautics Day (12 April, the date of Gagarin's flight). Text reads '**USSR. Cosmonautics Day. Moscow. D-242.12.4.74. The USSR pilot cosmonauts** '. The stamp shows the space dogs Ugolyok and Veterok.

studying the names of grocery stores, is taken by the professor from the streets to use in an experiment on rejuvenation by means of the insertion of a human pituitary gland and testicles. When Sharik, an amiable dog, is transformed into a human, he becomes Sharikov, an insufferable fellow. The professor notes that his dog's behaviorisms – Sharikov abruptly attacks cats, among other things – are really the best characteristics left in him.

Conversely, his indigenously human attributes – malice, lies, threats, and the mindless reciting of ideological slogans – are precisely what make Sharikov so objectionable. Fortunately, having gauged the full scale of Sharikov's menace, Professor Preobrazhensky turns him back into a dog. This satirical

novel, aimed at the new revolutionary 'order', was so popular among the Soviet intelligentsia that practically every line became an idiom.

A closer Laika prototype can be found in *Danko's Burning Heart* (1895), a heroic fantasy drawing on the myth of Prometheus, by the revolutionary writer Maxim Gorky.* In order to show the right path for his people the character Danko rips

* Maxim Gorky (1868–1936) was a writer and political activist who developed social realism in literature. Exiled by the Soviet government twice, he died while under house arrest in Moscow.

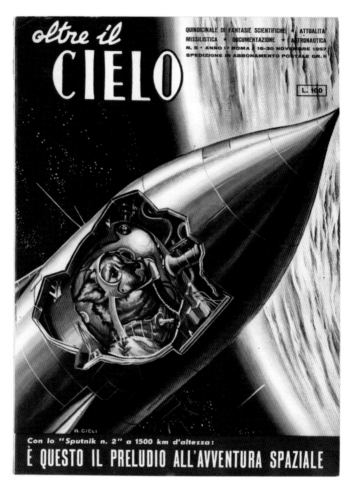

Con lo "Sputnik n. 2" a 1500 km d'altezza:

È QUESTO IL PRELUDIO ALL'AVVENTURA SPAZIALE

out his heart and carries it ahead of him as a torch, then dies. The symbolism and similarity is obvious but of course Laika had no choice as to whether she, drawing on the myth of Prometheus, wanted her heart to be used as a torch to light the way for humankind!

In his space novel *Omon Ra* (1992) Victor Pelevin resurrects Laika, or, rather, her ideological alter ego. The author satirises the ideology that had posthumously anthropomorphised the image of the space dog. In his novel everything is back to front: as the USSR has not yet developed the technology that

above: **Betty Boop tin tray, Mexico** (c.1958)
An illustration of Betty Boop walking her Laika-like space dog. Spanish text reads '**Lulu – refreshment bigger than your thirst**'.

left: ***Oltre il Cielo* magazine cover, Italy** (1957)
An artist's interpretation of Laika in Sputnik 2. Italian text reads '**With Sputnik 2 at 1500 km altitude: this is the prelude to the space adventure**'.

can send a cosmonaut back to Earth, the hero, Omon Ra, is trained for a mission to the Moon from which he will never return; Laika, by contrast, is ageing peacefully in the home of the flight commander.

> 'Out of a corner came a muffled howl, full of hatred; I glanced in that direction and saw a dog sitting on its haunches in front of a dark blue saucer with a picture of a rocket. It was a very old husky with completely bloodshot eyes. I was

above: **Toy watering can, Japan** (c.1958)
A space-themed child's watering can, depicting a dog in a Sputnik.

right: *Le Avventure di Layka* **book cover, Italy** (1957)
A children's book in which Laika meets aliens. Italian text reads '**The Adventures of Laika, Space Dog**'.

stunned, though not by its eyes, but by the tiny light green uniform covering its body, which was adorned with the Major General insignia, and, hanging from its chest, two Order of Lenin Medals.

"Let me introduce you," the flight commander said as he intercepted my stare. "Comrade Laika. The first Soviet cosmonaut. Her parents, by the way, were your and my colleagues. They also served in the corps, only in the north."

A small flask had appeared in the commander's hands, and from it he poured cognac into the saucer. Laika made a feeble attempt to bite his hand but missed, then resumed her muted howling.'

At the time of Laika's flight she had inspired unprecedented affection and compassion both in the USSR and in the rest of the world. Naturally, following his own space flight, Yuri Gagarin also became a worldwide hero. In 1962 he made a triumphant visit to London and Manchester. Noting the vast

TERESA NOCE
"ESTELLA"
LE AVVENTURE DI
LAYKA
CAGNETTA SPAZIALE

Gastaldi Editore

crowds that lined the streets just to catch a glimpse of the cosmonaut, it is rumoured that the prime minister Harold Macmillan said: 'There would have been twice the number if they'd sent the dog'.

The West felt genuine compassion for Laika. She was perceived as an innocent victim, caught up in the brutal Cold War drive to be first at any cost. To Soviet children, the story of Laika was a heroic fairy tale about a kind and intelligent dog that had flown away into space. To adults, her fate

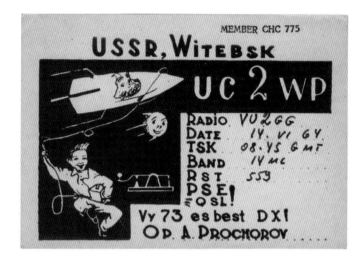

above: **QSL radio card, USSR** (c.1958)
Showing the first two Sputniks in flight with Laika peering out from Sputnik 2.

right: **Postcard, DDR** (1961)
An East German postcard showing the famous press image of Lyudmila Radkevich of the Institute of Aviation Medicine holding Belka (right) and Strelka (left). The date 20 August 1960 marks their famous flight into space.

ostensibly resembled their own. It was no accident that on the bas-relief of 'The Monument to the Conquerors of Space',* erected in Moscow in 1964, the image of Laika (or a similar little dog bearing an uncanny resemblance), appeared alongside images of nameless engineers and scientists whose identities could not be revealed. This 350-foot silver obelisk in the shape of an exhaust plume is crowned by a rocket ascending into the sky. It came to symbolise the hopes and dreams of an entire generation of Soviet people.

Located in front of the monument is a statue of Tsiolkovsky, the father of cosmonautics. It is believed that he invented the rocket capable of escaping Earth's gravitational pull under the influence of the philosophical ideas of Nikolai Fedorov. Fedorov argued that mankind's 'Common Task' should be to resurrect their fathers and forefathers, restoring them particle by particle from the cosmic dust. In accordance with his

* Designed by the sculptor A. P. Faidysh-Krandievsky.

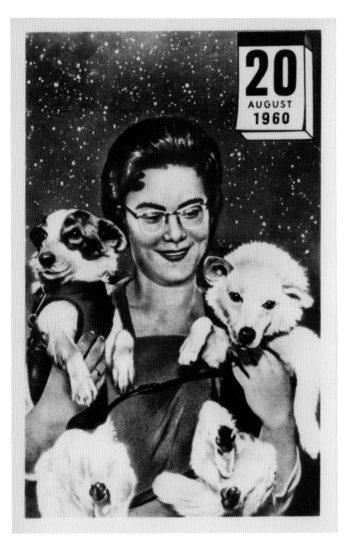

thinking, scientists and artists should join forces in the effort to regenerate the dead. The foundation of The Monument to the Conquerors of Space is the perfect place for this to happen: The Memorial Museum of Astronautics is housed here. Visitors are greeted by the stuffed, preserved bodies of Belka and Strelka – the most cheerful space dogs, ready and waiting to be reborn.

как интересно смотреть на землю с высоты!

Envelope, USSR (1961)
Text above reads '**How interesting it is to look at the ground from a height**'.
A quote from the popular children's book *The Adventures of Belka and Strelka*
by Yuri Galperin.

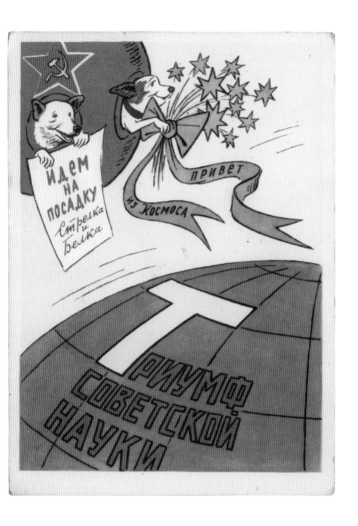

Postcard, USSR (1961)
An illustration by the artist M. Abramov. Belka holds a sign that reads '**We're going to land: Strelka and Belka**'; Strelka holds a ribbon that reads '**Greetings from Space**'; text on the Earth reads '**Triumph of Soviet Science**'.

Belka and Strelka can be considered the first 'space pop stars'. Fortunately they are characters in a fairy tale with a happy ending. Following their triumphant landing, they appeared on radio and television, and their portraits were featured in newspapers and magazines. They were chauffeured

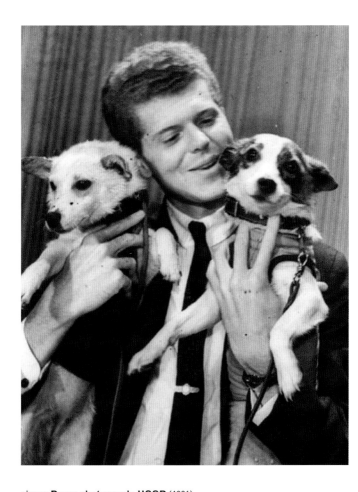

above: **Press photograph, USSR** (1961)
The American pianist Van Cliburn holds Belka and Strelka.

right: **Postcard, USSR** (1960)
An artistic interpretation by the artist A. Zavyalov of one of the photographs from the first press conference. Text reads '**Belka and Strelka**'.

to celebratory meetings with Soviet citizens: politicians, outstanding labourers, schoolchildren and celebrities – both Soviet and international – considered it an honour to be photographed with this famous pair. The renowned American pianist Van Cliburn, who came to Moscow on tour, happened to make their acquaintance by sheer luck. Belka and Strelka

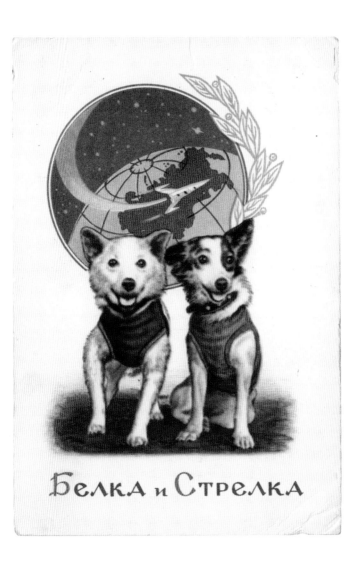

Белка и Стрелка

ran off during their TV interview at Moscow's Shabolovka broadcasting centre, and having darted through the nearest door, had found themselves as guests in the studio where Van Cliburn was recording his concert. Cliburn immediately recognised them, asking Lyudmila Radkevich of the Institute of Aviation Medicine (who had just managed to catch the

above: **Envelope, Lithuanian SSR** (1961)
An envelope celebrating one year since the flight of Belka and Strelka. The Lithuanian text reads '**First cosmonauts Belka and Strelka 1960 – 20. VIII – 1961, House of Culture, city of Siauliai. Philatelic circle**'.

top right: **Envelope, Bulgarian SSR** (1961)
A First Day Cover envelope with a stamp celebrating the flight of Belka and Strelka. Text reads '**II Soviet spacecraft. Belka and Strelka – 19 August 1960**'.

bottom right: **Envelope, Byelorussian SSR** (1960)
An envelope from the Minsk philately club, celebrating the flight of Belka and Strelka. Text reads '**Earth – Space – Earth. The second spacecraft. 19 – 20. VIII – 60. Minsk.**', text under the image reads '**Minsk. Stalin Prospect**'.

dogs), for permission to stroke them. It is difficult to determine who was more popular in 1960: Van Cliburn or Belka and Strelka... The meeting between the American celebrity and the Soviet space conquerors was promptly filmed and broadcast on the evening news,[*] the footage later found its way into documentaries on space exploration.

Portraits of the two dogs, adorably dressed respectively in red and green spacesuits, appeared in every conceivable place: on chocolates, matchboxes, postcards, lapel badges,

[*] This was not the first instance involving international celebrities being used in the reporting of 'Victories of Soviet Science for the Sake of the Entire Human Race' (the Communist Party terminology of the period). When the American singer Paul Robson was touring the USSR in 1957, he was asked to comment on the worldwide significance of the launch of Sputnik 1.

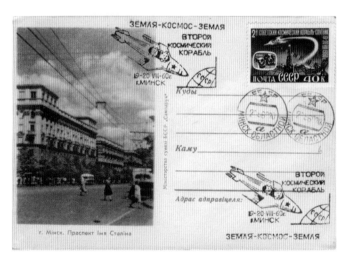

postage stamps and toys... In contrast to Laika, Belka and
Strelka had managed to attain fame during their lifetime.
Their images evoked smiles and a deserved sense of pride –
they were the first cosmonauts who had gone into orbit and
safely returned. In an additional first, their capsule had been
fitted with a camera that transmitted live images from space
to Earth in real time. Following Belka and Strelka's landing,

Exploit scientifique : les savants soviétiques ont suivi à la TV les deux chiennes, Fléchette (à dr.) et Ecureuil (à g.) pendant leur voyage. Ces extraordinaires documents photographiques ont été pris devant l'écran.

REPORTAGE
LUCIEN NAU

a documentary about the preparation for their flight – which included that first live space broadcast – aired on television. The whole nation watched Strelka merrily spinning in zero-gravity, while Belka, on the contrary, remained reserved and watchful. Afterwards, scientists regretted that they hadn't

Deux chiennes, après avoir fait dix-sept fois le tour de la Terre et parcouru 700 000 km en vingt-cinq heures, sont revenues vivantes au sol. Leur nom, Strelka (Fléchette), Belka (Écureuil). Leur nationalité : russe. Elles ont été ramenées à Moscou par avion. Elles ont pris un bain. Elles ont mangé avec bon appétit. Leur comportement est normal, leur examen physiologique excellent. Tel est le bilan de victoire clamé par Moscou, le samedi 20 août à 20 h 23. Spoutnik V, vaisseau cosmique de 4 600 kg, dans lequel les deux nouvelles héroïnes de l'espace avaient pris place, avait été lancé dans la nuit de jeudi à vendredi. Dans leur capsule étanche, elles avaient des compagnons : souris, rats, mouches, algues microscopiques, semences. Tout est revenu vivant. La capsule a été récupérée à 10 km du point de chute prévu, en un lieu qui n'a pas été révélé. Le retour sur terre s'est effectué le samedi matin entre 10 h et 11 h 30. Le « vaisseau cosmique » duquel la capsule avait été détachée a été également récupéré, probablement neuf heures plus tard. Ce qui est un autre exploit, car il pesait quatre tonnes. Maintenant, le vol de l'homme dans l'espace interplanétaire est possible. Il est même prochain.

Avant
le
départ

***Paris Match* magazine, France** (1961)
One of many newspapers and magazines to print the images of Belka and Strelka taken from the live footage beamed back to Earth. French headline reads '**Strelka and Belka photographed during their 700,000 km journey around the Earth**'.

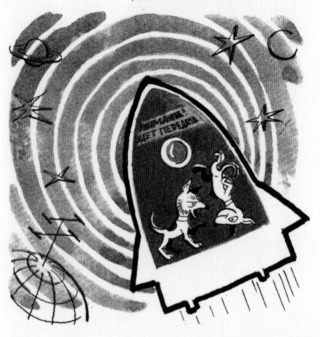

Для наблюдения за поведением животных на борту корабля-спутника была установлена радио-телевизионная система.

— Перестань ходить на голове, на тебя весь мир смотрит!

installed microphones in the cabin, so that the dogs could have been heard on Earth. (In fact, there had been microphones, but they were calibrated for the specific purpose of monitoring the noise level in the cabin, and not for recording the noise made by the dogs.) Where previously the only sound was the beep-beep-beep of the first Sputnik, the barking dogs gave Outer Space a new soundtrack (albeit one that could only be heard by the scientists on the ground). During their flight, as they and the American satellite *Echo 1* passed simultaneously over the Tyuratam cosmodrome (see page 122), both dogs began to bark at the same time. This coincidence caused a thunderous cheer at the Soviet Mission Control Centre, and some wished that the space dogs had 'taken a piss' in the direction of their

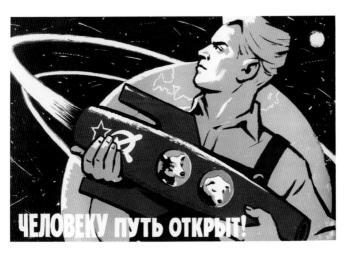

ЧЕЛОВЕКУ ПУТЬ ОТКРЫТ!

above: **Poster, USSR** (1960)
Space propaganda poster by the artist K. Ivanov. Text reads '**The way is open to man!**'.

left: Cartoon, *Crocodile* magazine, **USSR** (c.1960)
Text at the top reads '**To observe the behaviour of the animals on board the spacecraft, a radio-television system was installed**'. Text inside the rocket reads '**Attention! Transmission in progress**'. Text underneath reads '**Stop walking on your head, the whole world is watching you!**'.

American counterpart. However, the scientists would not share those memories until much later. On 20 August 1960, immediately after landing, Belka and Strelka became the heroes of not only official newspaper announcements, but also poems and stories.

Belka and Strelka's worldwide fame was intrinsically connected to the pathos of the Soviet technological revolution, one of the principal achievements of which was the conquest of space. Their celebrity status played a significant role in the confrontation between the two opposing ideologies of the Cold War. Most importantly, the image of Belka and Strelka had made space more 'human'. Whereas Laika's tragic end had split the world into two halves – those who would sacrifice the dog for the sake of winning the Space Race, and those who could not justify her death – the images of the two adorable dogs comically paddling in zero-gravity, dressed in their

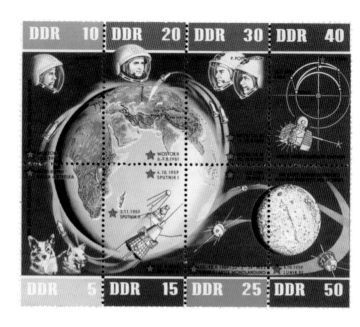

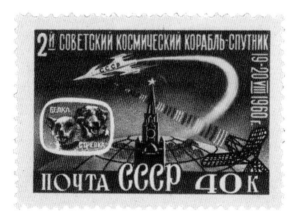

top: **DDR stamp souvenir sheet** (1962)

bottom: **USSR stamp** (1960)

top: **Korean stamp sheet** (1974)

middle: **German stamp** (1975)

bottom: **Bulgarian stamp** (1960)

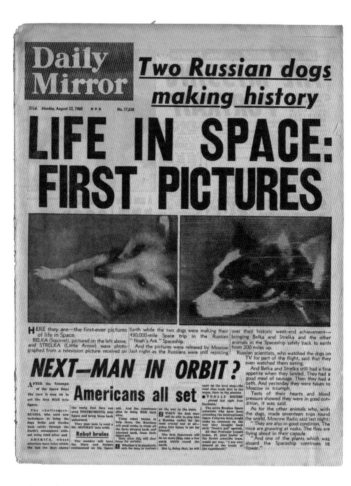

tailored spacesuits, seemed to have made the idea of the cosmos a little warmer. Space could now be perceived as home, perhaps faraway and fantastic, but already awaiting man, who was scheduled to visit very soon.

Fairy tales in Soviet literature were generally of a didactic nature, and endeavoured to give the mythical elements of the genre a strictly scientific explanation. An example is Lazar Lagin's fairy tale *The Old Genie Hottabych*, first published in 1935: the 1955 (second) edition was made into a film the following year. The story tells of a genie released in Soviet Moscow who finds himself completely powerless in socialist

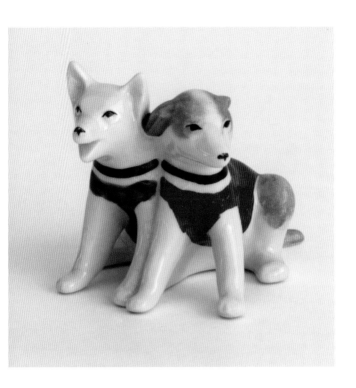

above: **Porcelain figurine, USSR** (1960)
A figurine of Belka and Strelka from the Dmitrovsky Porcelain Factory.

left: ***Daily Mirror* newspaper, Great Britain** (1960)
The front page of the *Daily Mirror* on 22 August 1960 uses the live images of
Belka and Strelka from Sputnik 5: 'the first-ever pictures of life in space'.

society, which is built upon the advancement of science and social equality. The genie's fabulous wealth and magical powers are useless in the utopian socialist kingdom, where fairy tales have long since become reality. He offers some young pioneers a ride on his magic carpet, but they forego this wizardry, having already flown in a real aeroplane. Eventually the genie capitulates, asking the pioneers to teach him about the science that gives man such power over nature.

Unlike this type of distinctly Soviet fairy tale, the animated film *Belka and Strelka, Star Dogs* (2010), revealed that the straightforward story of their space flight was insufficient for

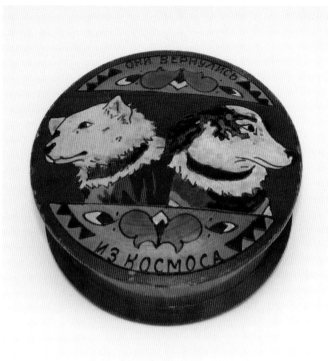

above: **Wooden box, USSR** (c.1960)
A handmade wooden box depicting Belka and Strelka. The text reads '**They returned from space**'.

right: ***Ogonyok* magazine, USSR** (1960)
The front page of the weekly magazine. The text reads '**Space! Waits for Soviet man to visit! Why did the little American cry?**'.

significant plot development. Perhaps that was because this new fairy tale about the canine space travellers was created in an era already capable of space tourism. Screenwriters Aleksandr Talal and John Chua gave the dogs a biography in the spirit of Disney characters, filled with amusing adventures. Additionally, this new post-Soviet tale of Belka and Strelka was enhanced by a love story that blossomed between Belka and a German shepherd, Kazbek, who was a military pre-flight trainer. According to this new tale, a puppy named Pushok (Fluffy) was born from their union, and Nikita Khrushchev

КОСМОС! ЖДИ В ГОСТИ
СОВЕТСКОГО ЧЕЛОВЕКА!

Одиннадцать картин И. И. Левитана

Почему плакал маленький американец?

gave him to the American President John F. Kennedy's daughter, Caroline. Pushok is delivered to the White House by a KGB officer. This part of the storyline is very close to events in real life, and perhaps hints at how the White House had initially interpreted this ideological present. In fact it was one of Strelka's (not Belka's) six puppies, named Pushinka, who was sent as a diplomatic gift to the United States. Fearing the Russians had found a way of secreting a bugging device on or in the puppy, she was thoroughly examined and scanned internally before being passed on to the president's family.

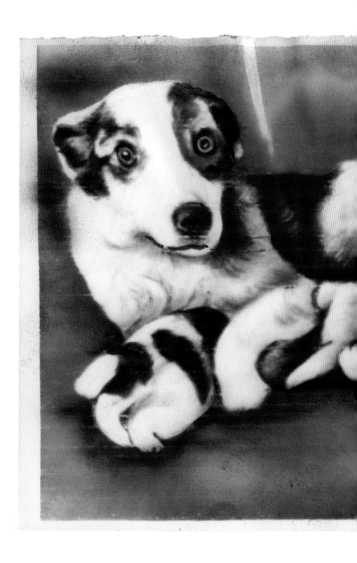

In the 2010 film the entire story is narrated by newly arrived Pushok, who shares the history of his remarkable family with the inhabitants of the White House.

By contrast Yuri Galperin's fairy tale *The Adventures of Belka and Strelka* (1961) contains few additional plot lines or deviations from the realities of the space mission. Nevertheless, it is a captivating read, conveying something of the festive

Press photograph, USSR (1961)
A photograph of Strelka with her litter of six puppies. The accompanying caption reads '**Strelka and her puppies are doing well. The birth proves that living beings can be protected from radiation in outer space. Strelka made 18 orbits of the Earth at an average height of 170 miles last August, before being returned to Earth with her companion, Belka**'.

Цена 10 коп.

atmosphere and sense of pride the Soviet people felt after the happy landing of Belka and Strelka. The story begins at a stray shelter where a space doctor chooses two dogs. These two friends are destined to work together. Initially, they are fed a delicious meat stew, which leads them to conclude that 'work' is a great thing. Then, after having their temperatures taken, and their hearts checked, they are delivered to a tailor, who makes their spacesuits. To strengthen them for their flight,

The *Adventures of Belka and Strelka* children's book, USSR (1961)
The popular children's book by Yuri Galperin.

they are given fish oil and vitamin injections. At first, the dogs can't work out how to behave, but they quickly get used to the idea of space discipline, learning not to jump or bark during the tests. Belka and Strelka are trained to wear their snug-fitting suits, which are attached to various wires. They courageously endure cold and heat in the training capsule, and are confined

The following text appears within the illustration panels:

Их даже покатали на самолёте. Как интересно смотреть на землю с высоты! Даже ни одной, самой большой собаки сверху не разглядишь. Дома и те, словно спичечные коробки, реки, как ручейки, дороги похожи на ниточки.

24

Ракета летит всё вперёд и вперёд. Теперь это уже маленькая звёздочка на небе, а телевизор показывает всё, что делается в кабине. Вот и собаки привыкли к полёту. Они спокойно едят желе.

36

Рядом с ними в маленькой клетке другие пассажиры — белые мышки. Сидят и, как ни в чём не бывало, грызут сухари. Пьёт воду в своей клетке большая крыса, в стеклянных баночках — плодовые мушки, а рядом с ними, под стеклом, зелёный цветок. Вот сколько пассажиров в ракете!

37

The Adventures of Belka and Strelka, USSR (1961)
Pages from the popular children's book by Yuri Galperin.

top: 'They were even flown in a plane! How interesting it is to look at the ground from such a height... You can't see a single dog from up here. Not even the biggest one. Even houses themselves are like matchboxes. The rivers are like little streams, and the roads look like threads.'

above left: 'The rocket keeps flying forward. It's now no more than a tiny star in the sky, and the television shows us everything that goes on in the cabin. The dogs have become used to the flight and peacefully eat their jelly.'

above right: 'There are other passengers in small cages next to them: the white mice, who are just sitting there crunching their croutons oblivious to everything; a big rat drinking water in its cage, and fruit flies in small glass jars. Under a glass next to them there is a green plant. This is how many passengers there are on board the rocket...'

right: 'They looked in surprise at the gleaming cars speeding home.'

for several days at a time in a cramped re-entry module, where they are unable to walk, only sit or lie down. Inside they learn how to eat gelatinous food delivered by an automatic dispenser. They are spun on a merry-go-round, and trained to tolerate future rocket noise by listening to recordings. They are tested on a vibrating table, and have to sleep in a brightly lit kennel. They are even flown in an aeroplane. But the most severe trial for the dogs is the ejector seat, in which they are

А звездолёт летит давно
В заоблачные дали.
Лучами звёздочки в окно
Тихонько постучали.

27

***Belka and Strelka* slide film, USSR** (1961)
A slide film of the children's story by Yuri Yakovlev, with images by the artist
V. Lihachyov. These slides would be projected in schools to bring the dogs'
adventures to a wider audience.

suddenly shot up into the air, descending slowly down by means of a parachute. Following all these ordeals the dogs are rewarded with a sugar lump or a chunk of *kolbasa* (a Russian sausage similar to salami). After completing these exhaustive tests they are carefully examined (even by a dentist), bathed in a tub, brushed, fed, and dressed in freshly ironed jumpsuits. Then Belka and Strelka are taken to the cosmodrome, and put into the cabin of a waiting rocket. The doctor strokes them and wishes them a safe journey and the dogs lick his hand in farewell. Once the rocket has blasted off, the scientists observe Belka and Strelka on their monitors. At first the dogs sit very quietly. Eventually, as they become accustomed to the flight, they eat some jelly. The rocket orbits the Earth eighteen times, and then its passengers land. The doctor welcomes them with their favourite delicacy: *halva* (a dense, sweet dessert made from sesame seeds and honey). Belka and Strelka become the most famous dogs in the world.

БЕЛКА и Стрелка

19 августа 1960 года в Советском Союзе был запущен в космос и возвращён на Землю космический корабль, на борту которого находились две собаки Белка и Стрелка.
Этим отважным космическим путешественницам и посвящён наш фильм.

Но двух подружек со двора,
Как видно не забыли
Их медицинская сестра
Везёт в автомобиле.

В далёкий путь
пошлём двоих,
Годы собак эти,
Но прежде посадим их
На маленькой ракете
Пускай освоят высоту
И жить привыкнут на лету.

Надели две дворняжки
Защитные рубашки.
– "Гав-гав!"
– "Тяв-тяв!"
Не попадёт нога в рукав.

Летают выше птицы
Хвостатые сестрицы
С землёй они прощаются
И снова возвращаются.

Два пассажира входят в дверь
Пора! Прощаться надо.
Назад не выпускать теперь
Хоть и страшновато.

Вдруг стали вес они терять
И стали, как пушинки.
Они не могут устоять,
Они плывут на спинке.

Прижавшись к тёмному окну
Холодными носами,
Собаки встретили луну
И крикнули ей сами:
– Гав-гав. Луна!
Тяв-тяв. Луна!
Ты очень хорошо видна!

– Я б съела пять костей подряд!
Сказала Белка Стрелке.
И тут же подал автомат
Ей завтрак на тарелке.

Так пролетев на корабле
Над самой крышей мира,
Вновь очутились на Земле
Два храбрых пассажира.

В простом дощатом конуре
Жила собака Белка
А рядом с нею во дворе
Жила собака Стрелка.
Они скреблись к нам лапой в дверь,
Играли с ними дети,
Но напечатаны теперь
Портреты их в газете.

КОНЕЦ

Редактор Г. Налещникова
Художественный редактор А. Морозов

Д-241-61

Студия "Диафильм"
Москва, Центр, Старосадский пер., д. № 7

165

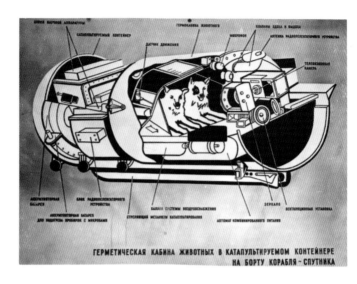

Every newspaper publishes their portraits, the dogs' only regret is that they are unable to read. Belka and Strelka are invited as guests on a radio show. However, with their space obedience training, they lie quietly without barking. So that the millions of children at home have an opportunity to hear the space travellers, the doctor resorts to playing a trick – he pretends to leave the studio without the dogs. Suddenly they start barking in a frenzy: 'Woof! Woof! You've forgotten about us!' and so the listening admirers hear the sound of the intrepid space scouts.

This science fantasy with a happy ending was extremely successful propaganda for promoting Soviet achievements in space exploration. Until perestroika, Belka and Strelka were officially considered the first creatures, (after Laika), to go into space, and, more importantly, safely return to Earth.

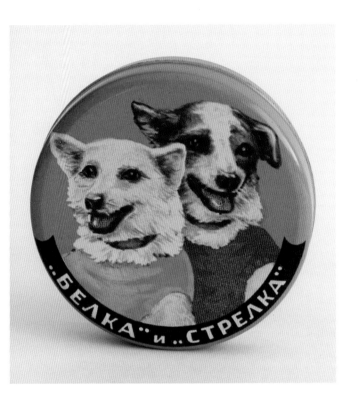

But this was not entirely correct. Belka and Strelka were in fact a backup crew. The original team of Chaika and Lisichka died tragically on 28 July 1960, when their rocket exploded on the launch pad.

As a direct consequence of Laika's death, the programme concentrated its efforts on securing a safe return to Earth for the next crew. This was the most important aspect of the flights for the lead spacecraft designer Sergey Korolev, especially as work continued to build a rocket capable of carrying man.

Chaika and Lisichka had been the favourite dogs at the institute. Lyudmila Radkevich later recalled how bright and lovable they were, in particular Lisichka. According to memoirs of Korolev's associates who were preparing the dogs for their flight, just before the launch he whispered in her ear: 'I really want you to return.' She did not. It was later suggested that

above: **Envelope, USSR** (1961)
A Belka and Strelka themed envelope. Text reads '**The first space travellers Belka and Strelka**'.

top right: **Envelope, USSR** (1961)
An envelope celebrating the return of Belka and Strelka. Text reads '**20.VIII.1960. The first space travellers Belka and Strelka**'.

bottom right: **Envelope, USSR** (c.1961)
An envelope celebrating the flight of Belka and Strelka. Text reads '**Cosmonauts Strelka and Belka**'.

sending a red-haired dog into space was a bad omen. Work began immediately preparing their understudies: Albina and Marquise. This is what Belka and Strelka were originally called, until the Commander-in-Chief of the Strategic Missile Force, Marshal Mitrofan Nedelin, decided that they sounded too French and bourgeois, and ordered that they be replaced with decent Russian names. Albina, who on the marshal's orders became Belka, had already completed a number of vertical flights. But for Strelka, formerly known as Marquise, this mission would be her first. The anecdote about the ejector seat that had frightened the dogs in Galperin's fairy tale, in reality referred to the newly developed on-board cosmonaut rescue system, which had been produced following the deaths of Chaika and Lisichka.

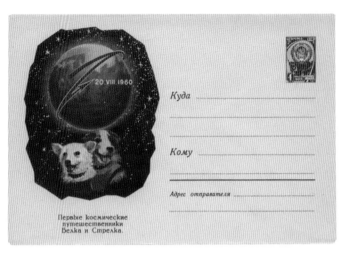

Alongside Belka and Strelka, the space mission included an ejecting container with twelve mice, insects, plants, fungi cultures, various germs, sprouts of wheat, peas, onions, and, taking into consideration Khrushchev's personal taste, kernels of corn.* In addition, the cabin contained twenty-eight lab mice and two white rats.

* Khrushchev was known as *Kukuruzshchik* (Mr Corn), because of his belief that the cultivation of corn was the solution to the country's livestock problem. The initial success of the crop was later undermined by its planting in unsuitable conditions, damaging both Soviet agriculture and Khrushchev's reputation.

The launch of the rocket containing Belka and Strelka took place on 19 August 1960, at 15:44:06. The deaths of Chaika and Lisichka had happened less than a month before, adding a particular anxiety to the mission. Only after the first orbit did the dogs begin to bark, Dr Vladimir Yazdovsky (lead scientist

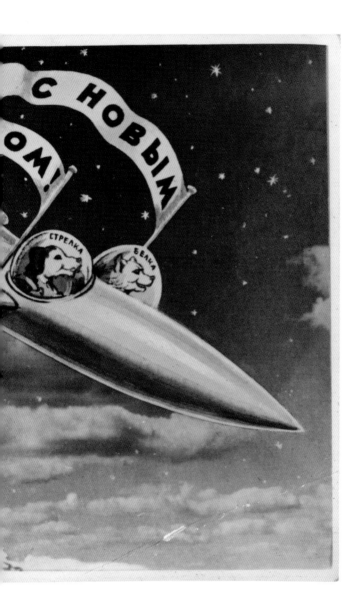

Postcard, USSR (1960)
A postcard showing Belka and Strelka in their rocket by the photomontage
artist Sveshnikov. The flags read **'Happy New Year'**, on the wing of the rocket
'USSR', inside the cockpits **'Strelka'**, and **'Belka'**.

top: **Badge, USSR** (c.1960)
A badge in the shape of a rocket, containing Belka and Strelka. The portholes of the rocket make the 'O's of the word: '***KOSMOS II***' (SPACE II).

above left: **Badge, USSR** (c.1960)
Belka and Strelka peer from the porthole of their spacecraft. Text reads '**19.08.1960. Belka and Strelka**'.

above right: **Badge, USSR** (c.1960)
The rocket's plume forms space for the text, which reads '**Belka and Strelka**'.

right: **Badge, USSR** (c.1960)
A lapel badge commemorating the flight of Belka and Strelka. Text around the outside reads '**First in the World**', '**19.8.1960**', inner text reads '**To return from space to Earth**'.

of biological research in the upper layers of the atmosphere and outer space) declared that as long as the dogs were barking, and not howling, they were sure to return to Earth. A huge step forward was the televisual transmission from the spacecraft, which allowed the scientists to closely monitor

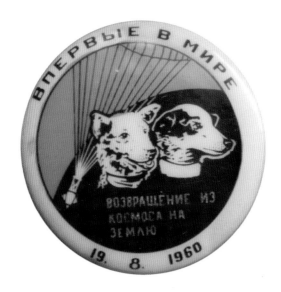

ВПЕРВЫЕ В МИРЕ

ВОЗВРАЩЕНИЕ ИЗ
КОСМОСА НА
ЗЕМЛЮ

19. 8. 1960

the dogs in flight for the first time. They became so quiet at the launch, that were it not for data from sensors attached to their bodies, it would have been difficult to ascertain whether they were still alive. As expected, owing to the g-forces of blast-off, their heart rates and breathing had speeded up, but they quickly returned to normal. However, on the fourth orbit, Belka began to wriggle out of her harness, barking, and vomiting. This reaction played a key role in the subsequent decision to send the first human cosmonaut into space for the shortest period possible: a single orbit. Belka and Strelka remained in flight for over twenty-four hours, allowing the scientists enough time to study the prolonged influence of zero-gravity and radiation on live organisms. During the eighteenth orbit, on 20 August, at 13:22:00 the order was given to decelerate, and a short time later the re-entry capsule containing the dogs landed safely on the ground. The success of Belka and Strelka's

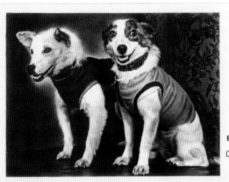

Белка
и
Стрелка

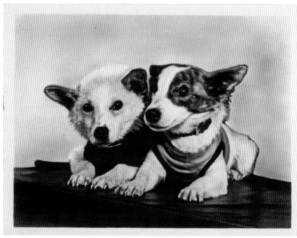

Белка
и
Стрелка

Postcards, USSR (1960)
Postcards featuring photographs taken at the first press conference. All texts read
'**Belka and Strelka**'.

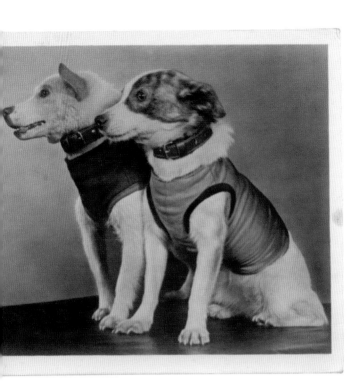

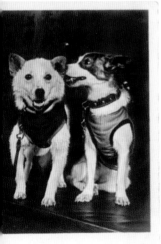

Белка и Стрелка

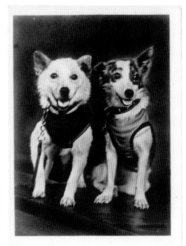

Белка и Стрелка

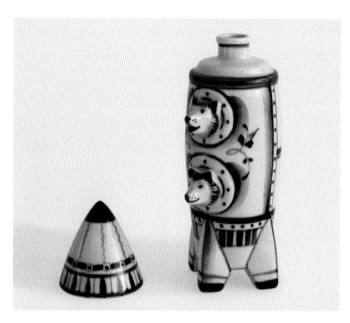

above: **Flask, USSR** (unknown)
A 'Gzhel' style ceramic Belka and Strelka porcelain flask.

right: **Press photograph** (1960)
Oleg Gazenko holds Strelka (left) and Belka (right) aloft at the press conference. In his memoirs, Gazenko referred to this as 'the proudest moment of his life'.

flight was announced immediately. The following day they were flown to Moscow. While the State Committee occupied itself deciding what was permissible to report about the successful space experiment and whether a commemorative obelisk should be erected at the site of the dogs' landing, Oleg Gazenko, acting of his own accord and at his own risk, took the space celebrities, together with Lyudmila Radkevich, to a specially organised international TASS press conference. According to Radkevich's memoirs, when their car stopped on route at a red light, passengers in nearby vehicles recognised the dogs and began applauding. As she entered the building she tripped over the doorstep and fell, but managed to keep a grip on her precious cargo. The chivalrous French journalists who came to her assistance drolly congratulated the dogs on their second safe landing. In a famous photograph from the

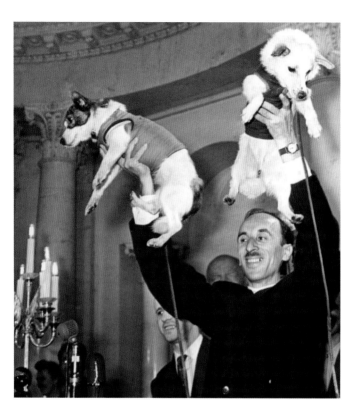

TASS press conference, Oleg Gazenko raises Belka and Strelka above his head as a living symbol of victory, a World Cup win in the conquest of Outer Space. Indeed, this was a considerable achievement. Now it was possible to send a man into the cosmos.

Immediately, the dogs, or more accurately the scientists, declassified in the aftermath of their space flight, were booked for numerous interviews. From respectable scientific journals through to children's publications such as *Murzilka*, the complete spectrum of the press was interested in their story, everyone was desperate to learn as much as possible about Belka and Strelka. They received fan mail from every corner of the world (which was answered by the aforementioned scientists). They attended both formal and informal gatherings, where they were paraded as the living incarnation of the

achievements of Soviet science and technology. At this time there was no pop culture in the USSR. Under socialism the niche occupied by popular culture in capitalist society was subject to strict ideological control. Paradoxically, Belka and Strelka became the first Soviet pop stars. The extensive

Postcard, USSR (1972)
A postcard depicting Belka and Strelka in the 'cockpit' of their rocket. By the artist L. Aristov, from the collection titled **'*Friends of Man*'**.

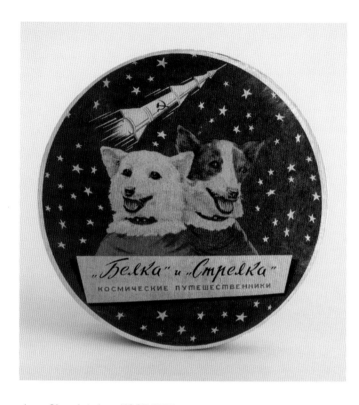

above: **Chocolate box, USSR** (1960)
A paper and cardboard box, produced at the Red October confectionery factory.
Text reads '**"Belka" and "Strelka" – Space Travellers**'.

right: **Confectionery tin, USSR** (c.1960)
A tin showing Belka and Strelka against a background of stars. Text reads
'**"Strelka" and "Belka"**'.

production of merchandise emblasoned with their image,
their ubiquity across all media, the overwhelming desire of
every Soviet citizen, regardless of their age or gender, to
meet the space dogs in person: these elements, and many other
factors traditionally associated with the cult of the pop star,
emerged during the mass-cultural phenomenon of Belka and
Strelka. The space dogs had very effectively played a starring
role in a society that propagated social equality. Because of
the strict secrecy surrounding the space programme, the
recognition ultimately owed to the scientists and engineers who

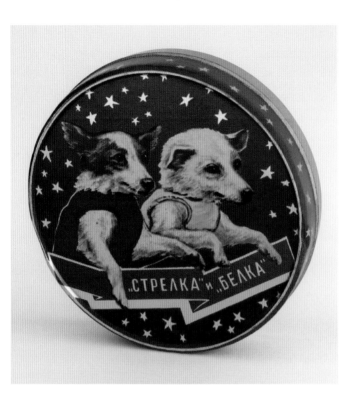

had prepared the spacecraft and its crew was bestowed entirely on Belka and Strelka. This secrecy also enforced the standard state methodology, which dictated that every outstanding achievement belonged to all Soviet people rather than any single individual. This claustrophobic atmosphere of anonymity was swept away in the universal wave of adoration for the four-legged cosmonauts. Not only had they become symbols of the new space era, but they were proof that a cosmonaut could return to Earth alive and well. In his memoirs the prominent space rocket designer Boris Chertok* revealed that Lev Grishin (the supervisor for the development of space rocket technology) had joked: 'Today we took the preliminary "dog" step, and tomorrow the main, human step will follow.' It is safe to say that the dogs had paved the way

* A co-worker of Korolev, and author of four volumes on Soviet space history.

for cosmonauts, not only into orbit, but also into popular culture. This pop culture, with all its idiosyncratic variety, was born in the USSR alongside the dawn of the space era. Space became so popular that every other café would be named 'Cosmos' or 'The Orbit'. Soviet industry produced vacuum cleaners of cosmic design, with corresponding model names, such as 'Saturn', or 'Rocket', as well as washing machines and children's bicycles designed in the shape of spacecraft. In a popular children's comedy *Welcome, or No Trespassing* (1964), directed by Elem Klimov, even a dog bears the name

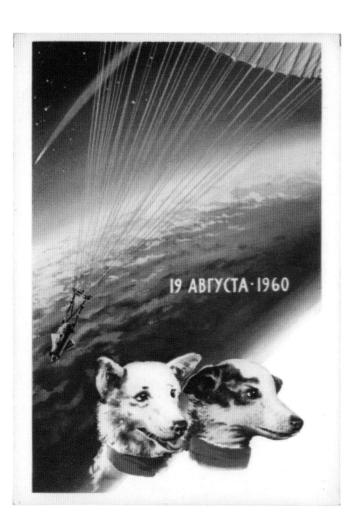

above: **Postcard, USSR** (1962)
A portrait postcard of Belka and Strelka, in the background their rescue capsule is parachuted back to Earth. Text reads **'19 August 1960'**.

top left: **Postcard, Ukrainian SSR** (1971)
A postcard of the 'Rocket' cinema, Kiev.

bottom left: **Postcard, Ukrainian SSR** (1973)
A postcard of the 'Cosmos' cinema, Kiev.

7 коп.

ДЛЯ ДОШКОЛЬНОГО ВОЗРАСТА
Познанская Мария Аввакумовна
**ПРО БЕЛКУ И СТРЕЛКУ
И ИХ ПУТЕШЕСТВИЕ**

Ответственный редактор Н. А. Терехова.
Консультант по художественному оформлению
П. И. Суворов. Технический редактор И. П. Са-
венкова. Корректор В. К. Мирантгоф.
Сдано в набор 4-IX 1964 г. Подписано к печа-
ти 9-IV-1965 г. Формат 70×90¹/₁₆. Печ. л. 1.25.
Усл. п. л. 1.46. (Уч.-изд. л. 1.57). Тираж 150 000.
ТП 1964 №84.
Издательство «Детская литература». Москва,
М. Черкасский пер., 1. Фабрика «Детская кни-
га» №2 Росглавполиграфпрома Государственно-
го комитета Совета Министров РСФСР по пе-
чати. Ленинград, 2-я Советская ул., 7. Заказ №454.
Набор текста изготовлен на машине «НФА».

'Cosmos'. Manufacturers in the USSR mastered the art of merchandising using the likenesses of Belka and Strelka. Portraits of human Soviet cosmonauts would follow this model.

Having achieved stardom, Belka and Strelka spent the rest of their lives peacefully in a monitored facility at the Institute of Aviation Medicine, where they were occasionally filmed and interviewed. Strelka had a litter of six healthy puppies, which gave the scientists an opportunity to study the effects of a prolonged orbital space flight on genetics. At the 1961 New Year festivities in the Kremlin, the biggest children's party in

above: **Confectionery tin, USSR** (1960)
These tins were given to young guests of the New Year's Eve party at the Kremlin. Text reads '**"Strelka" "Belka"'**.

left: *Belka and Strelka, and Their Journey*, **USSR** (1964)
The back cover of the children's book by M. Poznanskaya, with a romanticised image of how the dogs returned to Earth.

the country, guests were given tins of sweets adorned with a picture of the two space dogs in their green and red jumpsuits. In this illustration, Belka and Strelka are looking towards the heavens. Their portrait evokes the iconography of the heroic human pilots portrayed in Soviet paintings and posters: always moving upward, always towards the sky.

The Vostok spacecraft, which had carried Belka and Strelka, was perfectly 'mannable' (designed to carry a cosmonaut). It was obvious to everyone that the dogs were the forerunners of the first human space flight. Comic strips and cheerful

– Белка и Стрелка прибыли... Приготовиться к посадке следующему...

above: **Cartoon,** *Crocodile* **magazine, USSR** (1960)
A cartoon by the artist N. Lisogorsky. Text top and bottom reads '**At the Soviet Cosmodrome**', '**Belka and Strelka have arrived... Get ready for the next landing...**', text on the rocket reads '**USSR. Earth – Space – Earth**'.

right: **Press photograph, USSR** (1961)
Lyudmila Radkevich of the Institute of Aviation Medicine holds Chernushka (right) and Tishka (left), one of Strelka's puppies.

children's drawings of that period portray the landing of the dogs with a cosmonaut taking their place in the rocket. A cartoon by N. Lisogorsky (above) is suggestively captioned 'Belka and Strelka have arrived... Get ready for the next landing...' Yuri Gagarin's first manned space flight was less than a year away. In the remaining time there would be several more dog crews sent into space. Their function would be to convince the scientists beyond any doubt of the safety of these

flights. Mushka, Pchyolka, Damka, Zhulka, Chernushka, and finally Zvezdochka were sent to attempt orbital flights*. Zvezdochka and Chernushka would be commemorated with stamps, cards, and even memorials. But none of them achieved the same glory and recognition as Belka and Strelka.

The next orbital space flight, carried out on 1 December 1960, ended in failure. The trajectory of the re-entry module deviated from the programmed course, and when the system

* The dogs used on these flights are often confusingly referred to by other names (see list on page 232).

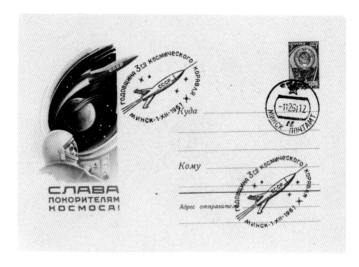

registered the risk of landing outside USSR territory, the on-board self-destruct mechanism was activated. Space secrets were not permitted to fall into foreign hands. The dogs Mushka and Pchyolka, who had orbited the Earth seventeen times, were killed.

On 22 December 1960, another canine crew were sent into space, but they didn't manage to enter orbit. The dogs Shutka and Kometa (also known as Zhemchuzhina and Zhulka – the dog names were frequently changed for security purposes), miraculously survived. The re-entry module made an emergency landing in the taiga, near the Podkamennaya Tunguska river, site of the infamous Tunguska explosion.* The temperature in this remote area was minus forty degrees, and it took the rescue team three days to reach the capsule. When they opened it they found that the mice, insects and plants were all dead, but somehow the dogs had survived. One of them, Zhulka (Kometa), was taken home by Oleg Gazenko. She lived happily in his house for another twelve years.

* On 30 June 1908 an asteroid or comet between 60–190 metres in size impacted on the Earth in the remote region of Tunguska, Siberia. On entering Earth's atmosphere, a combination of pressure and heat caused the object to explode at 8.5 kilometres above ground. The resulting blast destroyed 2000 square kilometres of forest, felling 80 million trees. The 'Tunguska event' remains the largest impact on Earth in recorded history.

above: ***Belyanka and Pyostraya in the Rocket*, USSR** (1961)
This children's book by V. Borozdin describes the work of two veteran space dogs, Belyanka (Whitey) and Pyostraya (Speckled) using photographs. The readers learn how they reached a height of 450 kilometres before safely returning to Earth. This achievement did not go to their heads: 'If by chance they came across a newspaper containing their portraits, they ran past, as if not noticing.'

left: **Envelope, USSR** (1961)
A Minsk envelope marking the first anniversary of Sputnik 6. The flight did not go to plan and was aborted to prevent the possibility of the technology falling into the hands of foreign powers. Both the dogs on board, Pchyolka and Mushka ('Little Bee' and 'Little Fly'), were killed. Text reads '**Glory to the Conquerors of Space!**'.

Nikita Khrushchev knew the Americans had developed a spacecraft capable of taking a man into space, and he had been pressuring Korolev to accelerate the Soviet programme. Despite this, the Chief Designer insisted on completing two further controlled flights, each making a single orbit, duplicating exactly the first human cosmonaut mission. The dogs who served as Yuri Gagarin's immediate forerunners flew solo alongside a mannequin named Ivan Ivanovich, dressed in the same orange spacesuit that would later be worn by the first cosmonaut. The mannequin's chest cavity, abdomen and hip area housed the entire spectrum of Darwinian evolution. This 'Noah's ark', as it was later christened by foreign journalists, contained mice, guinea pigs, and various microorganisms.

Chernushka's flight took place on 9 March 1961, Zvezdochka headed for orbit on 25 March 1961. Incidentally, she was originally called Udacha (Good Luck), but her name was changed because of superstition. Gagarin, who, together with the first space crew, was present at the launch, had named her Zvezdochka (Little Star). The first manned space flight was eighteen days away. Both Zvezdochka and Chernushka attained their share of fame. Just like their predecessors, they also appeared on postage stamps, cards, and badges. On 28 March 1961 the Soviet Academy of Science

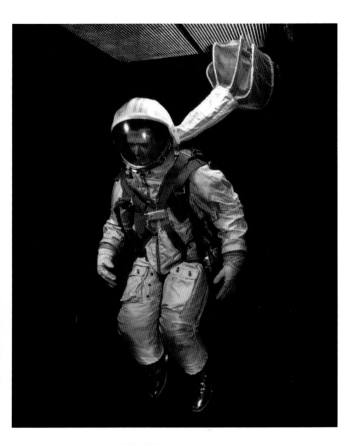

above: **Ivan Ivanovich, USSR** (1961)
The mannequin Ivan Ivanovich, dressed in a fully functioning Sokol spacesuit,
accompanied the dogs in the final two test flights before Gagarin's historic trip.

left: **Postcard, DDR** (1983)
A postcard celebrating the space era. It depicts a portrait of Korolev alongside
a type R-1 rocket. The German text reads '**The History of Space Travel: From
the Fire Arrow to Sputnik 1. S. P. Korolev 1906–1966. Organiser and Chief
Design Engineer of the USSR's high-performance rockets, missiles,
satellites and spaceships. Large Soviet missile R-1 launch on 18.10.1947**',
text in the postmark reads '**25 years of the space era**'.

held a press conference, summing up the results of the entire
series of experiments that had been conducted on board the
five 'manned' orbital spacecraft. Both Soviet and foreign
reporters took photographs of Zvezdochka, Chernushka, Belka
and Strelka. No one paid any attention to Gagarin, Titov, and

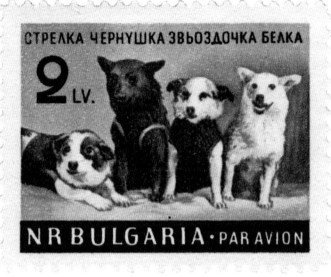

СТРЕЛКА ЧЕРНУШКА ЗВЬОЗДОЧКА БЕЛКА

2 LV.

N R B U L G A R I A · PAR AVION

above: **Stamp, Bulgarian SSR** (1961)
This stamp shows a group portrait taken at the press conference held on 28 March 1961. Text left to right reads '**Strelka, Chernushka, Zvezdochka, Belka**'.

right: **Confectionery tin, USSR** (1961)
A tin with a portrait of Chernushka. Text reads '**Chernushka**'.

the other cosmonauts sitting in the audience. At this point no one knew them. Pictures of the dogs were published in the next day's newspapers. One of the group portraits from this session was later reproduced on a Bulgarian postage stamp.

Upon the cessation of Chernushka's earthly existence, her body, as those of Belka and Strelka, was stuffed and displayed in the Institute for Medical and Biological Problems. A directive from Dr Vladimir Yazdovsky ordered that, for the purposes of Soviet space propaganda, Zvezdochka would see out her final years as an attraction at the Moscow Zoo. There an imposing placard announced: 'A bear cub Vasya, a wolf pup Petya, and a dog Zvezdochka – a participant in an orbital flight.' She later disappeared from the zoo, it's not clear if she escaped or was stolen. After perestroika both Chernushka and Zvezdochka had memorials erected at the sites of their landings. In 2006,

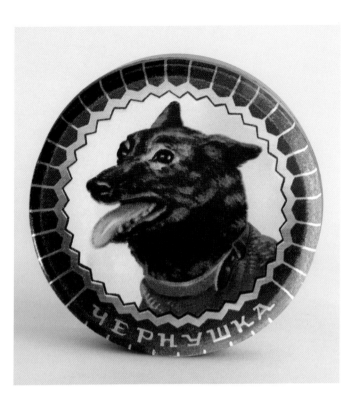

two years prior to the unveiling of the Laika memorial in Moscow, a Zvezdochka memorial was erected in the city of Izhevsk, close to the site where she was found. The memorial is engraved with 'Zvezdochka's list' – the names of around fifty scientists and engineers who had prepared her flight, and were fittingly paid a debt of recognition and appreciation.

In 2012 a Chernushka memorial was also erected in the town of Zainsk, Tatarstan. This was the surprise landing site of the capsule containing Chernushka and her unresponsive companion, the mannequin Ivan Ivanovich – who was initially mistaken for a foreign spy by the first locals to arrive at the scene.*

* Ivan Ivanovich was ejected from the capsule just before landing, descending to Earth by his own parachute. Locals arriving at the scene were confused as officials rushed to rescue a dog, ignoring what they presumed to be either a live spy or heroic cosmonaut. This problem was later solved by writing the word *MAKET* (dummy) on his forehead. Protocol demanded the spacecraft remained untouched until officials had deactivated its automatic self-destruct mechanism.

When Chernushka was extracted from the cabin by VIPs from Moscow, they proudly showed her to the Zainsk citizens. In 2011, fifty years after this event, which became a legend in the town, the teachers and students of a local school announced a contest for the design of a Chernushka memorial. The resulting monument features the trajectory of a spaceship looping around the Earth, with Chernushka's head juxtaposed against it, proudly gazing skywards. The memorial plaque reads: 'In honour of the cosmonaut dog Chernushka. The re-entry module Korabl-Sputnik 4 carrying the dog Chernushka on board, landed on Zainsk soil on 9 March 1961.'

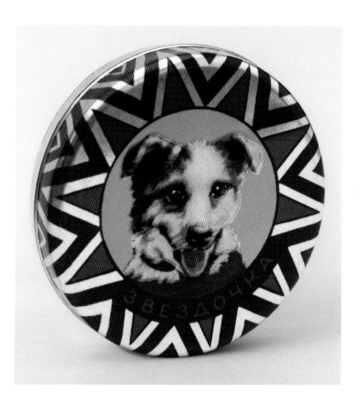

above: **Confectionery tin, USSR** (1961)
A tin with a portrait of Zvezdochka. Text reads '**Zvezdochka**'.

top left: **Envelope, USSR** (1962)
An envelope and stamp showing the rocket carrying Chernushka, with corresponding portrait stamp. Text reads '**09.III.1961 – 4th Soviet spacecraft satellite. Launch anniversary. Kaliningrad City Collectors Society**'.

bottom left: **Envelope, USSR** (1962)
An envelope showing the rocket carrying Zvezdochka, with corresponding stamp. Text reads '**25.III.1961. Launch anniversary of the 5th spacecraft, which landed in the designated region. Baku City Collectors Society – 1000. Baku 25.03.1962**'.

However the space dog saga did not conclude there. As technology improved, it became possible to increase the duration of manned missions, and so it was necessary to investigate how humans might be affected by long-term space flight. Consequently, on 22 February 1966, a man-made satellite was sent into orbit carrying two dogs on board:

Szellöcske Szenecske

Veterok (Little Wind) and Ugolyok (Little Piece of Coal). Their respective pre-flight names were Bzdunok and Snezhok, but these were changed, the former to sound more agreeable, and the latter to reflect the dog's colouring more accurately.* The dogs did not fare well on the long flight. In fact, they were taken out of orbit sooner than planned. After landing, Veterok and Ugolyok suffered from dehydration and bedsores. However, they were quickly rehabilitated, and later sired healthy puppies. Their flight lasted twenty-two days, which is still the record for a dog in orbit. At that time it was also the record for any living being in space, and would remain so for another five years, until it was finally broken by Soviet cosmonauts on the ill-fated Soyuz 11 mission.†

Because of the secrecy surrounding the programme, the precise number of dogs used in space experiments is unknown. Combining both vertical flights of geophysical rockets, and space flights of man-made satellites and spacecraft, it certainly

* Bzdunok means 'Little Fart', while 'Veterok' means 'Little Wind', 'Snezhok' is a snowball, and 'Ugolyok' is a piece of coal or ember. 'Snowball' was black, so this name was ironic.
† Soyuz 11 successfully docked with the Salyut 1 space station on 7 June 1971. After 22 days, the three cosmonauts returned to Earth on 30 June. However, the recovery team found the crew dead. A faulty valve had depressurised the cabin at a height of 168 kilometres, immediately asphyxiating them.

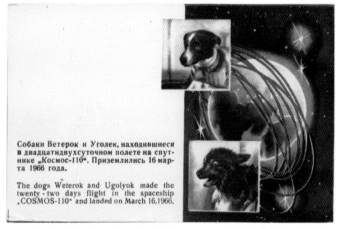

Собаки Ветерок и Уголек, находившиеся в двадцатидвухсуточном полете на спутнике „Космос-110". Приземлились 16 марта 1966 года.

The dogs Weterok and Ugolyok made the twenty-two days flight in the spaceship „COSMOS-110" and landed on March 16,1966.

top: **Envelope, USSR** (1966)
An envelope with a cartoon version of the dogs in their spaceship. Text reads '**22.2.1966 Cosmos 110. Ugolyok and Veterok**'.

above: **QSL radio card, USSR** (1969)
A radio card with a bilingual explanation of the historical flight of the dogs.

left: **Stamp, Hungarian SSR** (1966)
A portrait stamp. Text reads '**Hungarian Post. Little Wind, Little Piece of Coal. 39th Stamp Day 1966**'.

exceeds fifty, while over fifteen dogs flew twice or more. But to this day the most beloved dogs are Belka and Strelka. Now they will be immortalised in a monument by the artist Aleksandr Rozhnikov. A five-metre arrow will be erected in the town of Tomilino near Moscow, at the site of the Zvezda plant,

above left: **Badge, USSR** (1966)
An illustration of the dogs and an orbited Earth. Text reads '**Ugolyok and Veterok**'.

above right: **Badge, USSR** (1961)
An image of Zvezdochka. Text reads '**5th Soviet Spaceship. "Zvezdochka"**'.

right: **Commemorative plate, Ukrainian SSR** (c.1988)
A plate painted by the artist Prisyazhnyuk. Text reads '**"Strelka" "Belka"**'.

which manufactured life-support and emergency rescue systems for pilots and cosmonauts. This factory also made the spacesuits for the dog cosmonauts, and the cart that delivered them into the spacecraft cabin. The tribute portrays Belka and Strelka peering together from inside a giant space helmet, emblazoned with the letters 'USSR', and crowned with stars.

Memorials for these space dogs are, of course, an acknowledgement paid to the memory of those who were sacrificed in the name of science. In 1934 the celebrated Russian physiologist Ivan Pavlov (see page 49), who had conducted numerous experiments on dogs, commissioned a monument. The front reads: 'Although the dog, man's helper and friend, since prehistoric times has been sacrificed in the name of science, our dignity demands that this would always, without exception, be done without unnecessary suffering. ~ I. Pavlov.' The reverse side of the monument is engraved with the following: 'The dog, due to its long-standing disposition towards man, its intuitiveness, patience, and obedience, for many years, sometimes for its entire life, and sometimes even

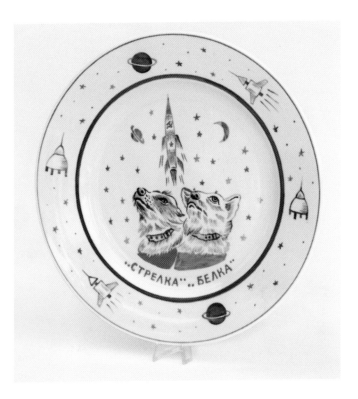

with joy, serves the experimenter. ~ I. Pavlov.' The idea to build a memorial to the space dogs had already emerged during the period that they were being sent into space. However, because the USSR was so oriented towards the future, the main symbol of which was the continuing space programme, this ambition remained unrealised.

After Belka and Strelka's flight, Soviet schools initiated lessons on how to be kind to stray dogs on the street, and the price of mixed-breed puppies at the Bird Market (the main pet market) in Moscow doubled; since any mongrel, if it wasn't too large, could become a cosmonaut. Even after Laika's tragic flight, Soviet citizens wrote letters to the government volunteering themselves to be sent into space. Requests for permission to fly into orbit increased immeasurably following the successful landing of Belka and Strelka. However, getting

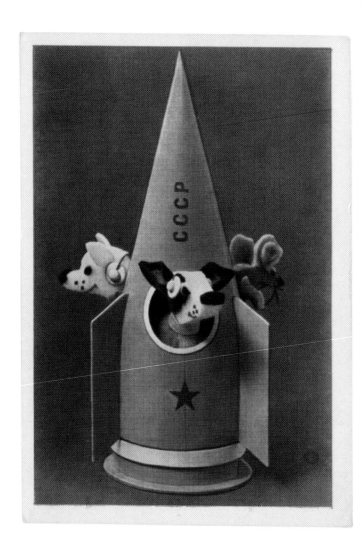

into the cosmonaut programme was as difficult as walking on the Moon. Only yesterday the space dogs had been so close, roaming the courtyards of Moscow, and yet today their heroic missions complete, so distant. They became an ideal and this ideal was perfectly human: to sacrifice yourself for the sake of humanity at large; and if you were lucky, become a hero, beloved by the whole country.

above: **Phonecard, USSR** (c.1991)
A phonecard showing two of the Soviet space monkeys that were to follow the dogs into space. Text reads '**1980s... The monkeys Dryoma and Erosha return from space**'.

left: **Postcard, USSR** (1962)
A postcard by the artist L. G. Zinoviev, the reverse side reads '**Belka and Strelka, Soviet Spacecraft Passengers**'. Text on the rocket reads '**USSR**'.

Following a temporary thaw in the Cold War in 1972, the United States and the Soviet Union signed the *Agreement Concerning Cooperation in the Exploration and Use of Outer Space for Peaceful Purposes*, and preparations began for the joint Apollo-Soyuz mission of 1975. In 1973 the Bion programme was formed, which included the launch of mini capsules designed to conduct biological research. In 1975 this programme became international. The important roles in Bion were no longer played by dogs, but by monkeys, who were sent into orbit in the company of birds, fish, flies, and other primitive organisms. These experiments were not as widely publicised as the flight of Belka and Strelka. Instead the whole country was watching the launches of the human cosmonauts, who upon landing would achieve instant fame and recognition, each receiving the title 'Hero of the Soviet Union'. It was now practically every child's fantasy to become a cosmonaut. In the meantime, rhesus macaque monkeys were about to embark on another strenuous space journey...

не видел
я там
никакого
бога

Matchbox label, USSR (1963)
A matchbox label from the souvenir set *The Way to the Stars*. The image shows Yuri Gagarin, the first man in space, with his Hero of The Soviet Union medal, awarded to him on 14 April 1961, two days after his famous flight. Text reads '**I did not see any God there**'. These words were reportedly spoken by Gagarin on his return from space. The exact origin of the quote is disputed, but it is usually attributed to the Khrushchev regime confirming the Soviet anti-religious ideology of the time.

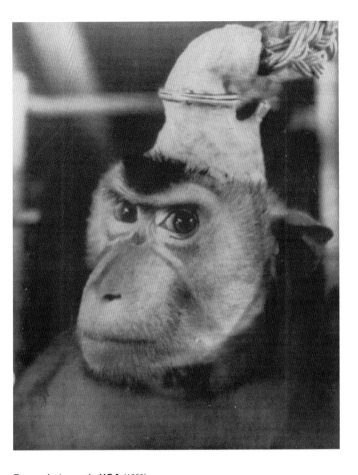

Press photograph, USA (1969)
The monkey Bonnie who died shortly after returning from his flight on the American spacecraft Biosatellite 3.

There is no mention of the dogs, monkeys, turtles, and quail eggs sent into space in John Milton's* famous poem *Paradise Lost*. But the poem could be read as a metaphor for the final stage of the space odyssey in which Soviet space dogs played such an important role. Milton's work was based on contemporary cosmology of the time: not only the ideas of

* John Milton (1608–1674) was an English poet, polemicist, man of letters, and government official, best known for his poem *Paradise Lost* (1667). This epic work details Satan's temptation of Adam and Eve, but also addresses theological and political themes of the time.

above: ***How a Bear Flies in Space***, **USSR** (1970s)
An illustration from the book by B. Mikhailov.

right: ***ABC Book***, **USSR** (c.1985)
A young children's book. Text reads '**Soviet man was the first to fly in space. He orbited the entire globe in a spaceship. The first cosmonaut Gagarin knows our entire planet. I am seven years old. I have a big dream – to be an astronaut. Dad told me: "Learn well every day, do your exercises, harden yourself. And your dream will come true."**'

Ptolemy,* but also the theories of Copernicus,† and Galileo,‡ who he had visited in his youth. In his poem, he calculated the distance from Hell to Heaven, estimated the perigee and the apogee, and depicted the creation of the international infernal capital Pandemonium in space.

Does this reference to Milton mean that sin, the loss of innocence and the perception of good and evil were motivational forces within the Soviet space programme? Yes and no. It is no secret that the Soviet ideology borrowed a lot from Christian morality, perhaps that is why atheism in the

* Claudius Ptolemy (c85–c165) was a Greco-Roman astronomer, mathematician, geographer and writer, known for the Ptolemaic system, where the universe revolved around Earth.
† Nicolaus Copernicus (1473–1543) was a Polish astronomer and mathematician, best known for his theory that the Sun was at the centre of the universe.
‡ Galileo Galilei (1564–1642) was an Italian physicist, astronomer, and philosopher. He built his own telescope and made many astronomical discoveries. His support of Copernicus' theory led to him being placed under house arrest for the last ten years of his life.

Со|ве|т|с|ки|й человек первым побывал в космосе. На ко|с|ми|че|с|ко|м корабле он облетел весь земной шар. Первого ко|с|мо|на|в|та Гагарина знает вся наша планета.

Мне уже семь лет. У меня большая мечта — быть космонавтом. Папа сказал мне: «Учись на отлично, каждый день занимайся зарядкой, закаляйся. И твоя мечта о|бя|за|те|ль-но с|бу|де|т|ся».

Soviet Union was so completely uncompromising, to the extent that churches, as sacred objects and places of worship, were demolished.* The new Soviet religion could not come to terms with the old, inherited, Christian religion. 'Paradise Lost' means that both canine and simian cosmonauts had been working to conquer space within the bounds of a dual system, of a world divided. This ideological refinement is accentuated by the fact that both space dogs and space monkeys were not simply

* As a direct result of the anti-religious campaign many churches were also converted into planetaria. Their architecture – the inside surface of domed copolas – lent itself perfectly to this adaptation, being easily transformed into a 'star theatre'.

above: **Postcard, USA** (1981)
A postcard of Ronald Reagan, 40th President of the United States. Referring to the Soviet Union as 'an evil empire', in 1983 he introduced the Strategic Defence Initiative (this system was nicknamed 'Star Wars' by its detractors, who believed the technology would not work).

right: **Poster, USSR** (1980)
A poster of Leonid Brezhnev, leader of the USSR between 1964–1982. Brezhnev's stockpiling of nuclear weapons (in the arms race against the USA) and investment in the army virtually crippled the Soviet economy.

victims sacrificed for the sake of a scientific experiment. They were perceived as real colleagues by the scientists, loved companions who could only be sacrificed as much as the scientists were willing to sacrifice themselves.

This human aspect of the Soviet programme, the scientists' personal attachment to the animals, was first witnessed by their American colleagues, when they were finally granted access to the Bion experiment. During this space collaboration, the ideological opposition between the forces of Good and Evil,

which had been the basis of propaganda in both the countries, disappeared. If the USA had actively used the name 'Evil Empire' borrowed from the film *Star Wars* (1977), then the USSR had castigated the intolerable conditions of capitalism. As the subject of long-term cooperation, the space programme became the solution to this antipathy. The Bion project played a special role in this.

Based on a military surveillance satellite, the Bion spacecraft had a life-support system designed to last for thirty days, and were used to carry out biological experiments. The Bion programme, in contrast to the dog programme, was not only concerned with the possibility of sending animals into space, but also with the complexities of sustaining living beings in orbit for extended periods of time. This Noah's Ark took lab mice, pregnant white rats, birds' eggs, fish, fruit flies, tissue samples and bacteria into space in an attempt to understand how space radiation, zero-gravity and overload influenced the operation

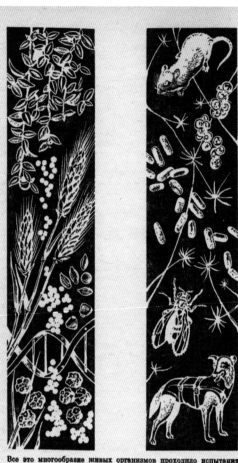

Все это многообразие живых организмов проходило испытания в космических полетах.

of the body's organs. Bio satellites allowed scientists to study the influence of zero-gravity and artificial gravity on living beings, and the possible fertilisation and embryonic development of mammals and birds' eggs. Mankind was progressing towards long-duration space flight. Tsiolkovsky had dreamed of this, designing a greenhouse on his proposed space platform. Filled with exotic fruits and vegetables, cosmonauts could produce enough food to be completely

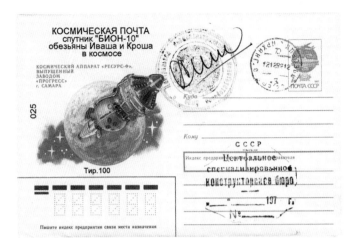

above: **Envelope, USSR** (1992)
An envelope showing the spacecraft Bion-10, which was launched on 29 December 1992 and returned on 7 January 1993. The monkeys Krosh and Ivasha were flown on board. Text reads '**Space-mail. BION 10 satellite. Monkeys Ivasha and Krosh in space. Spacecraft apparatus "Resource-F". Issued by the "Progress" factory, Samara**'.

left: *Living Organisms in Space*, **USSR** (1982)
An illustration from the book by L. V. Rebrova showing organisms flown in space. Text reads '**All these diverse living organisms have been tested in spaceflight**'.

self-sufficient during extended expeditions. This desire was also shared by his successor, Friedrich Zander, (who had been speculating on the possibilities of travel to Mars), as well as the Chief Designer, Sergey Korolev. Preparation for long-term flights was the speciality of the Soviet space programme.

It was necessary to monitor the cosmonaut in this unusual environment, to understand the body's reactions to the adverse conditions of space, and to find ways to negate any negative effects. It is no coincidence that the protagonists of Bion were monkeys, as their physical make-up is so similar to humans. A dog is a spaceman's best friend, as cosmonaut Valery Bykovsky said, rewording the universal saying 'a dog is man's best friend'; but it was a monkey that, in the process of its accelerated space evolution, became the predecessor of man in adapting to such an unusual environment.

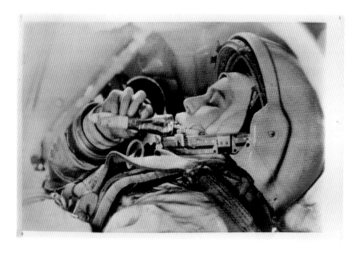

above: **Tereshkova in space, USSR** (1963)
On 16 June 1963, Valentina Tereshkova was the first woman in space. This picture shows her eating from a tube during her three-day flight. Soviet scientists examined the menstrual cycles of female monkeys to gauge the most favourable launch time.

right: **Postcard, USSR** (1963)
A portrait postcard of Valentina Tereshkova. Text reads '**Citizen of the Union of Soviet Socialist Republics, the world's first woman cosmonaut USSR, Hero of the Soviet Union. Valentina Vladimirovna Tereshkova**'.

Children of workers at the Plesetsk Cosmodrome* made up names for these space pioneers according to the Russian alphabet. The first monkey crew, which launched in 1983, were called Abrek and Bion (the latter named in honour of the programme). They spent five days in orbit. Unlike the orbital dog crews, the monkey teams were exclusively male, as it was believed that their organisms were stronger than those of their female counterparts. On board these 'Space Adams' would perform simple tasks and be exposed to overpressure. They were then returned to their troop, and kept under close observation by the doctors and workers at the primate centre. Female monkeys were only used on the ground. They were

* The Plesetsk Cosmodrome was founded in 1957. Due to its position (800 kilometres north of Moscow) it is only suitable for certain types of launches. Kept secret by the Soviets, its existence was discovered by a British physics teacher in 1966, who after analysing the orbit of the satellite Cosmos 112, deduced that it could not have been launched from the Baikonur Cosmodrome.

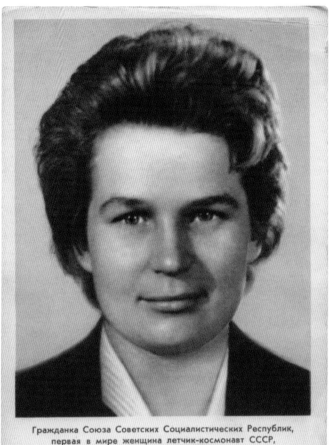

subjected to the same pressure overloads that would be experienced by Valentina Tereshkova, the first woman in space. Studying the female monkeys also helped determine the optimum time to launch, in relation to a woman's biological cycle. Chimpanzees, squirrel monkeys, pig-tailed macaques, rhesus macaques and crab-eating macaques took part in the American space exploration programme. Rhesus macaques were the passengers of six Bion crews sent into space between 1983 and 1997. The candidates had been selected from the

above: **The first Sukhumi monkeys, USSR** (c.1928)
A photograph showing a handler walking some of the new residents in the grounds of the Sukhumi Institute.

right: **Space monkey toy, USA** (c.1960)
A spinning monkey toy. When the cord at the base is pulled the monkey turns on its central pivot.

primate study centre in Sukhumi. This was the first such Soviet facility and since the moment of its creation, had been surrounded by unbelievable rumour and legend.

The Sukhumi Institute of Experimental Pathology and Therapy,* (later renamed as Research and Development Establishment of Experimental Pathology and Therapy), was founded in 1927. The first monkeys were sent there from French Guinea[†] on the initiative of Ilya Ivanovich Ivanov (1870–1932), an outstanding biologist who specialised in inter-species breeding, who was a pioneer in the artificial insemination of

* Sukhumi was part of the Georgian Soviet Socialist Republic from 1921–1989.
† Now the Republic of Guinea, in West Africa.

animals. According to legend, of the three female chimpanzees artificially inseminated with human sperm, two died on the journey to the research centre, and the third on arrival. Their autopsies showed no signs of pregnancy. A pubescent orangutan, Tarzan, also died at the centre as a result of being fed improperly and the unsuitable climate. Official records state that, out of the fifteen apes sent by Ivanov to the USSR from French Guinea, only two baboons and two chimpanzees survived. It was while in French Guinea that the scientist had performed experiments in an attempt to create an ape-man. In keeping with the utopian Soviet ideology, Ivanov intended to create a new man – or to be more exact, to find the 'missing link'. The government of French Guinea,

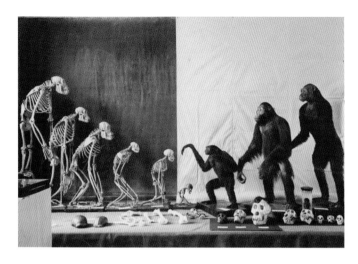

above: **Museum display, USSR** (c.1907)
A photograph of a display in The State Darwin Museum, Moscow, opened in 1907.

right: **QSL radio card, USA** (c.1962)
The card shows two photographs of Ham, the first monkey launched into space on 31 January 1961.

whilst initially supportive, became strongly opposed to the scientist's work, following his attempts to inseminate local women with sperm from anthropoid apes. Despite this, it is speculated that such procedures were performed at the Sukhumi centre. (The insemination of female apes would have been extremely complicated due to the difficulties with delivery of the sperm.) These experiments supposedly proved Charles Darwin's theory of the origin of species (which was held in high regard by the Soviets), and accordingly disproved religious beliefs in the divine origin of man. Allegedly there were even volunteers – women who, because of the strength of their ideological beliefs, were prepared to undergo artificial insemination in order to give birth to a new creature. In 1930, the experiment was stopped. Ivanov was arrested and exiled to Alma-Ata (now Almaty in Kazakhstan), where he died in 1932. His attempts to create a new being in order to prove the concept of materialism were then classified. The Sukhumi centre became famous as a leading scientific institute, playing

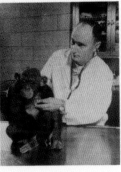

JAKARTA, INDONESIA, ZONE 28

a huge role in the fight against dangerous illnesses. It attracted many tourists during the Soviet era, who enjoyed watching the antics of the thousands of monkeys and apes living there. In the war between Georgia and Abkhazia (1992–93) the centre was bombed, and the animals fled. Many died from artillery fire, gunshots, the cold, and starvation. Some apes were transported to Veseloye, a village close to Sochi, and to the Adler ape centre, a subsidiary of the Institute of Medical Primatology. A number of employees also escaped there, following the apes.

Today visitors to the Adler Institute are greeted by a Bion spacecraft, complete with two stuffed monkeys crammed into their cosmonaut capsules. To minimise stress during the flight, monkeys were sent into space in pairs, in individual capsules with windows so they were able to see each other. Before the space flights all the monkeys, just like their dog counterparts, were put through intensive preparation in the Institute of Biomedical Problems near Moscow, under the direction of Oleg Gazenko. About twenty of the strongest macaques were chosen from the Adler Institute. Candidates for the flight and their backup pilots were only selected after long periods of training. All the monkey pilots would have their tails removed so they could fit into their cosmonaut capsules. They would also

have electrodes implanted in their brains. In his memoirs Oleg Gazenko professed that it was impossible not to feel pity for the outstretched monkeys, lying on the surgical table with wires protruding from the shaved crowns of their heads. However, the USSR was careful not to repeat the American mistake of 1969, when due to an overload of experimental assignments, the macaque named Bonnie died of heart failure just eight hours after returning to Earth.

In 1974 the Russians unexpectedly offered to collaborate with America in experiments on the Soviet biosatellite. This helped the Americans to reduce their expenditure on space research significantly, as all the transportation costs (take-off

Inside the left illustration: "They put Sam inside the rocket."

Inside the right illustration:
"Good-by, Sam," says Doctor Bob.
"Good-by, Sam," say the men.
Then they all go away,
and Sam is all alone.

34 35

above and left: ***The Monkey in the Rocket*, USA** (1962)
Cover and spread from the children's book by Jean Bethell and Sergio Leone. The story presents a necessarily sanitised version of the American space programme, where the monkey 'Sam' is safely recovered from his journey into space.

preparation, placing into orbit, and landing) were absorbed by the Soviet side. Bion was regularly launched into space, and the experiments performed on board gave significant insights into how living beings adapted over the course of longer-term space journeys. But in 1983 the results became truly spectacular. For the first time the Soviet space programme sent rhesus monkeys into space on board Bion 6. In total, twelve monkeys participated in the 'Bion' programme. They reacted to g-load and long-term zero-gravity in different ways. Abrek (a member of the first crew), behaved like a natural-born astronaut. However, his partner Bion suffered for seventy-two hours before gradually managing to adapt to his unusual circumstances. According to Oleg Gazenko, three days after his return, the monkey died from a bowel obstruction from eating too many sweets. The scientists determined that this was caused by a congenital defect, unconnected to the space flight. The next crew – Verny and Gordy (Russian for 'Faithful' and

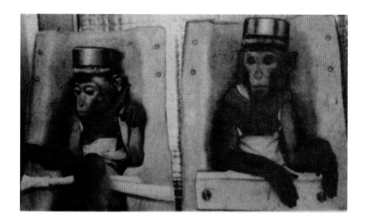

above: **Dryoma and Yerosha, USSR** (1987)
Dryoma (left) and Yerosha (right) flew on Bion 8 from 29 September to 12 October 1987. Dryoma was later given to Fidel Castro as a diplomatic gift.

right: **Envelope, USSR** (1997)
An envelope commemorating Bion 11, the final launch in the programme. Main text on the left reads '**Bion-11. Launch 24.12.1996. 1 GIK Plesetsk "Soyuz-U". Landing 07.01.1997 Kazakhstan**'. Text next to the photographs reads '**Cosmonauts "Lapik" and "Multik" in space flight training**'.

'Proud') – flew for almost seven days. The third crew were extremely troublesome, in particular the space monkey Yerosha. During the flight he partially loosened his hand, and proceeded to rip off his telemetric data wires, then he damaged the power supply system. To save him from dying of hunger, he was fed with a concentrated briar juice that was usually only given as a reward for a successfully accomplished task. It is rumoured that Yerosha and his fellow American monkey astronaut, once free from their space ties, became excited and began to masturbate.* It is difficult to say whether this is actually true. It's likely that this anecdote appeared because of the monkey's name, which carries allusions to the verb 'to rumple' in the Russian language. After their flight Yerosha's crew mate Dryoma was introduced to Fidel Castro, who liked the monkey so much that he was given to him as a diplomatic gift.

* The American space monkey Enos (the first monkey in orbit) was reported to have behaved in the same way during his flight, however this rumour was later disproved.

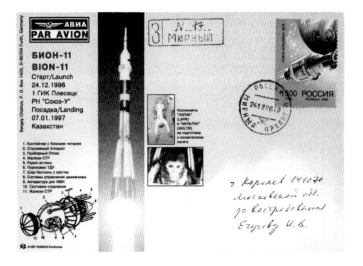

The last crew spent fifteen days in space, from 24 December 1996 until 7 January 1997. This flight of Multik and Lapik was sponsored by the Americans. By that time the Soviet Union had ceased to exist, so there was no funding for the space programme. After landing, Multik died in surgery, following an adverse reaction to anaesthetic. Multik's death was the end of the monkey space programme. The USA refused to participate further, even though another satellite launch with two apes had already been planned. The experiments were stopped as a result of both the influence of public opinion, and the lack of resources. In 2010 the monkey Krosh, a space veteran, died at the age of twenty-five. He and his comrade Ivasha were sent into space for twelve days at the end of 1992. He spent his final years with his offspring at the Adler Institute, where he lived as an honorary retiree – the last monkey-cosmonaut in Russia.

Russian monkeys still take part in the space programme, but now they work on Earth. Their characteristics are still tested at the Institute of Biomedical Problems near Moscow, where the space monkeys were previously trained. Today they find methods to overcome the negative effects of zero-gravity and ionising radiation during long space flights. Now monkeys have

above: ***Captain Radex's Trip to the Moon with Dubby the Monkey***, slide
story, **USA** (c.1961)
A children's story told in slides using photographed models. In this image
(number 1 of 5) Captain Radex decides to go to the Moon. Dubby the monkey wants
to go too. Text on the slide case reads '**On Earth in his cabin, Captain Radex,
Sergeant Evan and Dubby, the monkey, study plans to take them to the
Moon. "Our ship, The Moonbeam, that we planned for years is finished,"
says Captain Radex. "We leave tomorrow for the Moon!" "I'm going with
you," Dubby says.**'

right: **Envelope, Romania** (1993)
An envelope commemorating 30 years since the French launch of Félicette the cat
on board the Veronique AGI. The cat was recovered alive after a fifteen minute
flight. Text reads '**30 years of space flight, the cat FELIX in the rocket
Veronique. October 18, 1963 Launch at Hammaguir (French Sahara).
Ploiesti Philatelic Club**'.

contracts with scientists, signed by the biomedical ethics
commission of the Russian National Bioethics Committee.
The use of monkeys in the Russian Space Programme continues
to be controversial. In 2008 the Russian Space Agency
announced that a monkey from the Sukhumi centre could
become the first creature sent to Mars. This provoked protests
from the European Space Agency and animal protection
organisations. Similar protests took place when it was suggested

that monkeys might be exposed to long-term radiation within the 'Mars 500' programme. The Russian Federation has now abandoned the idea of sending higher mammals into space, especially dogs and monkeys. After a long break, the new biosatellite 'Bion M1' was launched in 2013, carrying microorganisms, snails, geckos and Mongolian gerbils on board. The Mongolian gerbils died because of a fuse failure.

Grain, protozoans, fish eggs and quails' eggs have been flying with astronauts in orbit for a long time. In most countries ethical issues forbid the sending of higher mammals into space. Today one can say that monkeys, cats (however cats almost immediately proved unfit for flights) and dogs have been replaced by human space tourists, who join the experiment voluntarily. Konstantin Tsiolkovsky thought that animals should not be sent into space, proposing that in the future all rocketeers would be vegans. According to Tsiolkovsky, if we gradually stopped using pets and livestock, it would result in the eventual disappearance of domestic animals from Earth and space. Will astronauts take living creatures with them into space as food or friends? Will a dog really become the best friend of the cosmonaut, by sharing the hardships of living in space, or will ethics make this situation impossible?

Soviet society perceived space as heaven. Following the flight of Yuri Gagarin a popular anecdote told of how one representative from a socialist country asked another if he

above: **'Moon' Station, USSR** (1964)
An image of workers on the Moon, from the children's book by P. Klushantsev.

right: **Children's Playmate** Magazine, **USA** (c.1962)
Cardboard cut-out clothing for the space age. The artist has '**... used authentic spacesuits for these cut-outs, except for the puppy ... but if boys and girls go into space, their pets will have to go too!**'.

knew about the Soviet people flying into space. His companion answered with a question: 'Have all the Soviet people left for space?' He received a disappointing answer: 'No, only one of them did'. However it wouldn't be an exaggeration to say that practically all Soviet people dreamed of flying into space. It was somewhere free of pain and earthly concerns, including gravity. In the 1960s and 1970s this idea of a new space heaven was a utopia, which perfectly fitted the utopian Soviet ideology, supported by science, technology and modernisation. Faith in progress and an ability to sacrifice oneself for the common goal became the foundation for personal and communal heroism, forcing the citizens to work miracles. For the sake of the great goal it was possible not only to sacrifice oneself, but also other living creatures, who were believed to possess such human qualities as courage and dedication...

For lasting fun with these cut-outs of Bruce and Margo, remove these pages from PLAYMATE and paste on thin cardboard before cutting and assembling.

Jean Tatalman, our space fashion artist, has used authentic space suits for these cut-outs, except for the puppy... but if boys and girls go into space, their pets will have to go too!

This ideology finally died, along with the collapse of the USSR.* It was replaced by another mass-media ideology that also demands sacrifice, no longer for the common goal, but for personal glory instead.

The future Mars One expedition, which has accumulated more than 200,000 volunteers from all over the world, offers a one-way ticket. The crew members will stay on the planet as both colonists and participants of a reality show. The expedition, co-founded by the Dutch entrepreneur Bas Lansdorp, is also backed by the creator of the *Big Brother* television phenomenon, who plans to stage live, around-the-clock broadcasting of the future colonists of Mars. This scenario echoes George Orwell's novel *1984*, in which 'Big Brother' is the name of the totalitarian dictator who embodies the eye of providence in a future that has replaced God, and therefore conscience.

At the beginning of the twentieth century, Mars became a symbol of revolution. It is thought that the Soviet symbol – the red pentagram – emerged thanks to the novel *The Red Star*

* Formally 1991, but the USSR had been crumbling long before this.

above: **Matchbox label, USSR** (1963)
A matchbox label from the souvenir set *The Way to the Stars*. Text reads '**To Mars**'.

right: **Postcard, USSR** (1977)
The Yuri Gagarin statue at Star City, the training centre for cosmonauts. Unveiled in 1971, it has become a tradition that space crews lay flowers here before and after their missions.

(1908), by Alexander Bogdanov. Soviet fantasy authors believed that in the near future Mars would become Soviet. This faith in the inevitable conquest of Mars was in accord with Lev Trotsky's ideas about the permanent revolution, Mars was perceived as a part of the Soviet future. This was also the case with the Moon, our closest neighbour. In Vasili Zhuravlev's science fiction film *Space Voyage* (1935), made with direct involvement of Tsiolkovsky, a cat was sent to the Moon to check the possibility of its inhabitation. Conversely, at the beginning of the nineteenth century, the motif of Mars the attacker

appears in western fiction: from H. G. Wells' novel *The War of the Worlds* (1898), to recent blockbuster science fiction films, Mars is consistantly perceived as a source of hostile aggression, threatening humanity. Today it is possible that the red planet might become a 'brave new world' where everything can be simulated, and there is neither suffering nor compassion. Meanwhile, in the Gagarin Cosmonaut Training Centre in Zvezdny City (Star City), Mars is explored from the safety of special simulators. Here simple actions are performed against a background of deserted Martian landscapes. In artificially

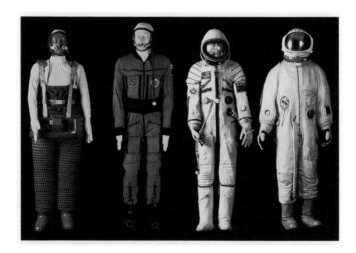

above: **Postcard, USSR** (1988)
A postcard showing the *Penguin* spacesuit, which contained internal elastic tensioning elements to add resistance to movement and help combat muscle deterioration in space. The full-pressure suit (far right) is the same type as worn by Alexei Leonov on 18 March 1965, during the first ever space walk.

right: **New Year bunting, USSR** (1962)
Space-themed New Year bunting depicting four and two-legged cosmonauts.

generated conditions of sparse gravity, cosmonauts rehearse how to walk wearing the overwhelming burden of terrestrial beings – the heavy spacesuit.

It seems there will be no place on Mars for space monkeys or dogs, at least they are not currently mentioned in the programmes of any future space mission. In the past, people travelled with their pets on long journeys, not simply as a live food reserve, but also for companionship. Daniel Defoe's Robinson Crusoe was first spared from loneliness on a deserted island by the presence of two cats, and a devoted dog, which had a very serious handicap – he could not speak. Will man travel to space alone?

Once space was perceived as a place of salvation, now it has turned from serving an ideology into a media opportunity. Today, space is a 'Paradise Lost'. The planned missions to Mars could be compared to John Milton's vision of the bridge between Hell and the New World. According to Nikolay

Fedorov's philosophy, space dust should be collected in order to recreate and resuscitate our forefathers, who are dissipated across the cosmos. Perhaps in the future, Martians will help us tame such new forms of existence. Perhaps then the Space Man will consider the first space dogs, monkeys, cats, geckos, mice, rats, snails, turtles, fruit flies, or even bacteria, that were sent into orbit, to be their ancestors.

мы не
достаточно
почерпнули
из этого
полета, чтобы
оправдать
смерть собаки

Artificial Satellites of Earth: 100 Questions and Answers, **USSR** (1958)
The cover of a book informing the public about the Soviet space programme.
Text above reads '**We did not learn enough from the mission to justify the
death of the dog**'. A quote from Oleg Gazenko, who trained and supervised the
animals involved in the Sputnik 2 project.

1

22/07/1951
DOGS: Дезик / Dezik [M] and
Цыган / Tsygan (Gypsy) [M]
ROCKET: R-1V ALTITUDE: 62m / 100km
RESULT: Recovered safely

2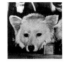

29/07/1951
DOGS: Дезик / Dezik [M] and Лиса / Lisa (Fox) [F]
ROCKET: R-1B ALTITUDE: 62m / 100km
RESULT: Parachute failed, both dogs died

3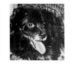

15/08/1951
DOGS: Чижик / Chizhik (Siskin) [M] and
Мишка / Mishka (Little Bear) [M]
ROCKET: R-1B ALTITUDE: 62m / 100km
RESULT: Recovered safely

4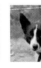

19/08/1951
DOGS: Рыжик / Ryzhik (Ginger) [M] and
Смелая / Smeliy (Courageous) [M]
ROCKET: R-1V ALTITUDE: 62m / 100km
RESULT: Recovered safely

5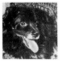

28/08/1951
DOGS: Чижик / Chizhik (Siskin) [M] and
Мишка / Mishka (Little Bear) [M]
ROCKET: R-1B ALTITUDE: 62m / 100km
RESULT: Failed, both dogs died

6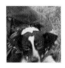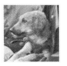

03/09/1951
DOGS: Непутёвый / Neputeviy (Scamp) [M] and
ЗИБ / ZIB (acronym for Missing Dog Bobik) [M]
ROCKET: R-1B ALTITUDE: 62m / 100km
RESULT: Recovered safely

7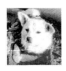

26/06/1954
DOGS: Лиса / Lisa-2 (Fox) [F] and
Рыжик / Ryzhik-2 (Ginger) [M]
ROCKET: R-1D ALTITUDE: 62m / 100km
RESULT: Recovered safely

8

02/07/1954
DOGS: Дамка / Damka (Little Lady) [F] and
Мишка / Mishka-2 (Little Bear) [M]
ROCKET: R-1D ALTITUDE: 62m / 100km
RESULT: Recovered safely, Mishka-2 died

9

07/07/1954
DOGS: Дамка / Damka (Little Lady) [F] and
Рыжик / Ryzhik-2 (Ginger) [M]
ROCKET: R-1D ALTITUDE: 62m / 100km
RESULT: Recovered safely, Ryzhik-2 died

10

26/07/1954
DOGS: Лиса / Lisa-2 (Fox) [F] and
Рыжик / Ryzhik-3 (Ginger) [M]
ROCKET: ALTITUDE:
RESULT: Recovered safely

11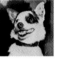

25/01/1955 or 25/06/1955
DOGS: Рита / Rita [F] and Линда / Linda [F]
ROCKET: R-1E ALTITUDE: 62m / 100km
RESULT: Recovered safely, Rita died

12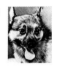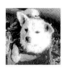

05/02/1955
DOGS: Бульба / Bulba [F] and
Лиса / Lisa-2 (Fox) [F]
ROCKET: R-1E ALTITUDE: 62m / 100km
RESULT: Recovery failed, both dogs died

13

04/11/1955
DOGS: Кнопка / Knopka (Button) [F] and
Малышка / Malyshka (Little One) [F]
ROCKET: R-1E ALTITUDE: 62m / 100km
RESULT: Recovered safely after 3 days

14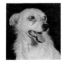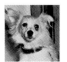

14/05/1956
DOGS: Альбина / Albina (Whitey) [F] and
Козявка / Kozyavka (Little Gnat) [F]
ROCKET: R-1E ALTITUDE: 62m / 100km
RESULT: Recovered safely

15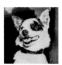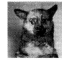

31/05/1956
DOGS: Линда / Linda [F] and
Малышка / Malyshka (Little One) [F]
ROCKET: R-1E ALTITUDE: 62m / 100km
RESULT: Recovered safely

16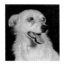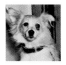

07/06/1956
DOGS: Альбина / Albina (Whitey) [F] and
Козявка / Kozyavka (Little Gnat) [F]
ROCKET: R-1E ALTITUDE: 62m / 100km
RESULT: Recovered safely

17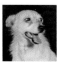

14/06/1956
DOGS: Альбина / Albina (Whitey) [F] and
Козявка / Kozyavka (Little Gnat) [F]
ROCKET: R-1E ALTITUDE: 62m / 100km
RESULT: Recovered safely

18

16/05/1957
DOGS: Дамка / Damka-2 (Little Lady) [F] and
Рыжая / Ryzhaya (Redhead) [F]
ROCKET: R-2A ALTITUDE: 132m / 212km
RESULT: Recovered safely

19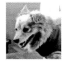

24/05/1957
DOGS: Джойна / Dzhoyna [F] and
Рыжая / Ryzhaya (Redhead) [F]
ROCKET: R-2A ALTITUDE: 132m / 212km
RESULT: Cabin decompression, both dogs died

20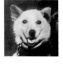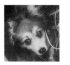

25/08/1957
DOGS: Белка / Belka (Squirrel) [F] and
Модница / Modnitsa (Fashionable) [F]
ROCKET: R-2A ALTITUDE: 132m / 212km
RESULT: Recovered safely

21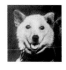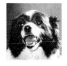

31/08/1957
DOGS: Белка / Belka (Squirrel) [F] and
Дамка / Damka-2 (Little Lady) [F]
ROCKET: R-2A ALTITUDE: 132m / 212km
RESULT: Recovered safely

2

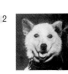

06/09/1957
DOGS: Белка / Belka (Squirrel) [F] and
Модница / Modnitsa (Fashionable) [F]
ROCKET: R-2A ALTITUDE: 132m / 212km
RESULT: Recovered safely

3

03/11/1957
DOG: Лайка* / Laika (Barker) [F]
ROCKET: R-7, Sputnik 2 ALTITUDE: Orbital
RESULT: No recovery system, died in space

* also known as: Кудрявка / Kudryavka (Little Curly), Лимончик / Limonchik (Little Lemon),
Жучка / Zhuchka (Little Beetle) and Muttnik

4

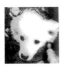

21/02/1958
DOGS: Пальма / Palma (Palm) [F] and
Пушок / Pushok (Fluffy) [M]
ROCKET: R-5A ALTITUDE: 280m / 451km
RESULT: Cabin decompression, both dogs died

5

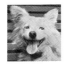 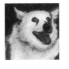

02/08/1958
DOGS: Отважная / Kusachka / Otvazhnaya (Biter /
Brave One) [F] and Пальма / Palma-2 (Palm) [F]
ROCKET: R-2A ALTITUDE: 132m / 212km
RESULT: Recovered safely

6

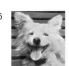 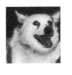

13/08/1958
DOGS: Отважная / Kusachka / Otvazhnaya (Biter /
Brave One) [F] and Пальма / Palma-2 (Palm) [F]
ROCKET: R-2A ALTITUDE: 132m / 212km
RESULT: Recovered safely

7

27/08/1958
DOGS: Белянка / Belyanka (Little Whitey) [F]
and Пестрая / Pestraya (Spotted) [F]
ROCKET: R-5A ALTITUDE: 280m / 451km
RESULT: Recovered safely

8

 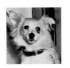

19/09/1958
DOGS: Дамка / Damka-2 (Little Lady) [F] and
Козявка / Kozyavka (Little Gnat) [F]
ROCKET: ALTITUDE:
RESULT: Recovered safely

29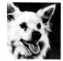

31/10/1958
DOGS: Кнопка / Knopka (Button) [F] and
Жульба / Zhulba [F]
ROCKET: R-5A ALTITUDE: 280m / 451km
RESULT: Parachute failed, both dogs died

30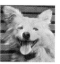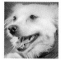

02/07/1959
DOGS: Отважная / Otvazhnaya (Brave One) [F]
and Снежинка / Snezhinka (Snowflake) [F]
also flown with rabbit Marfusa
ROCKET: R-2A ALTITUDE: 132m / 212km
RESULT: Recovered safely

31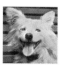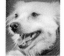

10/07/1959
DOGS: Отважная / Otvazhnaya (Brave One) [F]
and Жемчужную / Zhemchuzhnaya* (Pearly) [F]
ROCKET: R-2A ALTITUDE: 132m / 212km
RESULT: Recovered safely

* After flight 30 Snezhinka was renamed Zhemchuzhnaya

32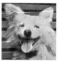

15/06/1960
DOGS: Отважная / Otvazhnaya (Brave One) [F]
and Малёк / Malyok (Small Fry) [M] also flown
with rabbit Zvezdochka (Little Star) [F]
ROCKET: R-2A ALTITUDE: 132m / 212km
RESULT: Recovered safely

33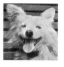

24/06/1960
DOGS: Отважная / Otvazhnaya* (Brave One) [F]
and Жемчужную / Zhemchuzhnaya (Pearly) [F]
ROCKET: R-2A ALTITUDE: 132m / 212km
RESULT: Recovered safely

* Otvazhnaya's participation in this flight is questioned

34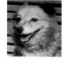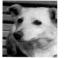

28/07/1960
DOGS: Лисичка / Lisichka (Little Fox) and [F]
Барс / Bars / Chaika (Panther / Seagull) [F]
ROCKET: R-7, Vostok prototype ALTITUDE: Was to be orbit
RESULT: Exploded during launch, both dogs died

35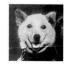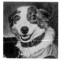

19/08/1960
DOGS: Белка / Belka / Albina (Squirrel) [F] and
Стрелка / Strelka / Marquise (Little Arrow) [F]
ROCKET: R-7, Sputnik 5 ALTITUDE: Orbital
RESULT: Spent one day in orbit, recovered safely

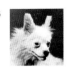

16/09/1960
DOGS: Малёк / Malyok (Small Fry) [M] and
Пальма-2 / Palma-2 (Palm) [F]
ROCKET: R-2A ALTITUDE: 132m / 212km
RESULT: Recovered safely

22/09/1960
DOGS: Отважная / Otvazhnaya* (Brave One)
[F] and Нева / Neva [F]
ROCKET: ALTITUDE:
RESULT: Recovered safely

* Otvazhnaya's participation in this flight is questioned

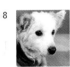

01/12/1960
DOGS: Мушка / Mushka (Little Fly) [F] and
Пчёлка / Pchyolka (Little Bee) [F]
ROCKET: R7, Sputnik 6 ALTITUDE: Orbital
RESULT: Spent one day in orbit, capsule was
destroyed, both dogs died

22/12/1960
DOGS: Шутка* / Shutka / (Joke) [F] and
Кометка† / Kometa (Comet) [F]
ROCKET: R-7 ALTITUDE: Was to be orbital
RESULT: Upper stage failed, dogs recovered
after a suborbital flight

* also known as: Дамка / Damka (Little Lady) and Жемчужина / Zhemchuzhina (Pearl)
† also known as: Красавка / Krasavka (Cheater) and Жулька / Zhulka (Beauty) and Жемчужную /
Zhemchuzhnaya (Pearly) and Снежинка / Snezhinka (Snowflake)

09/03/1961
DOG: Чернушка / Chernushka (Blackie) [F]
also flown with mannequin Ivan Ivanovich
ROCKET: R7, Sputnik 9 ALTITUDE: Orbital
RESULT: One orbit, recovered safely

25/03/1961
DOG: Звёздочка / Zvezdochka (Little Star) [F]
also flown with mannequin Ivan Ivanovich
ROCKET: R7, Sputnik 10 ALTITUDE: Orbital
RESULT: One orbit, recovered safely

22/02/1966 to 16/03/1966
DOGS: Уголёк* / Ugolyok (Little Piece of Coal) [M]
and Ветерок† / Veterok (Little Wind) [M]
ROCKET: Voskhod, Cosmos 110 ALTITUDE: Orbital
RESULT: Recovered safely after a 22 day flight

* also known as: Снежок / Snezhok (Snowball)
† also known as: Вздунок / Bzdunok (Little Fart)

The preceding chronological list of dog flights has been made with the best information available. Where no photograph of the dog exists, or it is uncertain that a photograph is correct, the box has been left grey. Due to the nature of the Soviet space programme some details were never revealed and others were even intentionally confusing. Dogs were sometimes given the same name as a previous dog that had been killed in flight and some dogs were named more than once.

In a situation where a flight was declared 'safely recovered' but one dog died, this was usually because different methods of recovery were being tested on each dog: they were sometimes ejected from the capsule at different heights, sealed in their own personal compartments. This meant that one dog might return to Earth safely, while the other might experience potentially fatal complications.

Compiled by Marianne Van den Lemmer.

The images in this book have come from the following collections:

Aaron George Bailey:
pages 28, 29, 82, 83, 123, 156, 184, 229.

FUEL:
pages 6, 9, 11, 15, 16, 17, 19, 20, 21, 22, 24, 25, 26, 30, 32, 35, 36, 37, 39, 42, 46, 47, 48, 50, 52, 53, 54, 56, 57, 62, 64, 67, 71, 73, 78, 81, 84, 91, 99, 100, 101, 102, 103, 106, 109, 110, 112, 113, 116, 129, 130, 143, 145, 152, 154, 170, 173, 175, 177, 178, 182, 183, 188, 189, 190, 192, 193, 196, 202, 207, 208, 209, 210, 211, 212, 213, 214, 216, 218, 219, 220, 224, 226, 227, 228.

Marianne Van den Lemmer:
pages 10, 12, 13, 18, 23, 27, 31, 38, 40, 41, 44, 45, 51, 57, 58, 60, 61, 65, 66, 68, 69, 70, 72, 74, 75, 76, 77, 85, 86, 88, 89, 90, 92, 93, 94, 95, 96, 97, 98, 104, 105, 107, 108, 111, 114, 115, 118, 119, 120, 121, 122, 124, 125, 126, 127, 128, 131, 132, 133, 134, 135, 136, 137, 138, 139, 140, 144, 146, 147, 148, 149, 153, 155, 157, 158, 160, 162, 163, 164, 164, 166, 167, 168, 169, 172, 174, 176, 181, 185, 187, 194, 195, 197, 199, 201, 205, 206, 215, 217, 221, 222, 223, 225, 230.

Moscow Design Museum, Moscow, Russia:
page 180.

Museum of Cosmonautics and Rocket Technology, St Petersburg, Russia:
pages 14, 59, 150, 151, 186, 198, 200.

National Air and Space Museum Smithsonian Institution, Washington, USA:
page 191.

Cover: FUEL

Olesya Turkina wearing an *Orlan* (Sea Eagle) MK-T spacesuit, for extra-vehicular activity. Star City Cosmonaut Training Centre, Moscow, Russia, 2013.

Dr. Olesya Turkina is Senior Research Fellow at the State Russian Museum, St. Petersburg, and Head of MA Program in Curatorial Studies at the Faculty of Liberal Arts and Sciences, St. Petersburg State University.

She has worked on numerous exhibitions, including *MIR: Made in the XXth Century* at the Russian Pavilion at the 48th Venice Biennale, 1999; *Observatory, Central Astronomical Observatory of the Russian Academy of Sciences* at Pulkovo, 2007. She is contributor to many publications including *El Cosmos de la Vanguarda Rusa. Arte y exploracion especial 1900-1930, Sala de exposiciones de la Fundacion BOTIN*, Santander, 2010. She has been a member of The Russian Federation of Cosmonautics since 1999. She has worked on a series of films dedicated to the Russian Space dream *The Chain of Flowers* (Levsha, 2000); *The Common Task*, (2004); and *The Great Soviet Eclipse*, (2008) in collaboration with the Museum of Jurassic Technology, Los Angeles.

Photograph: Jerneja Rebernak, KSEVT (Cultural Centre of European Space Technologies), Slovenia.

First published in 2014
Reprinted in 2015, 2017, 2019, 2022

Murray & Sorrell FUEL Ltd
FUEL Design & Publishing
33 Fournier Street
London E1 6QE

fuel-design.com

The publishers would especially like to thank the following people for generously
giving their time and expertise:
Margarita Baskakova, Aaron George Bailey, Anna Benn, Julia Goumen, Marianne
Van den Lemmer, Paul Van Looveren, Philippe de Quimper, Djamilia Raevsky,
Jim Reichman, Alyona Sokolnikova, Fergal Stapleton, Rebecca Warren.

Distribution by Thames & Hudson / D. A. P.
ISBN: 978-0-9568962-8-5
Printed in China

Венера